IMAGES
of America

SCRIPPS INSTITUTION
OF OCEANOGRAPHY

On the Cover: Student Roger Revelle hangs a Nansen bottle to collect a water sample off the side of R/V *Scripps* at an unknown date early in the 1930s. He would go on to become director of Scripps Oceanography and the most transformative leader in the institution's history. (Courtesy of the University of California San Diego Special Collections and Archives.)

IMAGES
of America

SCRIPPS INSTITUTION OF OCEANOGRAPHY

Robert Monroe

ARCADIA
PUBLISHING

Copyright © 2021 by Robert Monroe
ISBN 978-1-4671-0641-2

Published by Arcadia Publishing
Charleston, South Carolina

Printed in the United States of America

Library of Congress Control Number: 2021930785

For all general information, please contact Arcadia Publishing:
Telephone 843-853-2070
Fax 843-853-0044
E-mail sales@arcadiapublishing.com
For customer service and orders:
Toll-Free 1-888-313-2665

Visit us on the Internet at www.arcadiapublishing.com

This book stands on the shoulders of fundamental Scripps Institution of Oceanography histories written by icons such as Helen Raitt and Elizabeth Shor and amplified by dedicated Scripps Oceanography archivists and librarians including Deborah Day and Peter Brueggeman. There is always more to the story, so I hope this volume leads the reader to explore more of the history of one of the most important academic centers in the world.

Contents

Acknowledgments		6
Introduction		7
1.	"A Laboratory Capable of Great Things"	11
2.	The Biological Colony	29
3.	Scripps Goes to War	47
4.	The Golden Age of Exploration	57
5.	Uncovering Climate Change	89
6.	A New Mission	101
Bibliography		127

ACKNOWLEDGMENTS

Photographs in this book are provided by the University of California (UC) San Diego Special Collections and Archives and are the property of the University of California Regents unless otherwise indicated. Special thanks go to retired Scripps Oceanography archivists Peter Brueggeman and Deborah Day and scientists Lanna Cheng, Richard Somerville, Margaret Leinen, and others for their review and advice. Thanks also to UC San Diego photographer Erik Jepsen for his outstanding imagery, Lynda Claasen and Matt Peters of UC San Diego Special Collections and Archives for their research, and members of the Scripps Oceanography Heritage Committee who volunteer their time to keep the institution's history alive.

INTRODUCTION

What comes to mind when you think of San Diego? You might conjure up a beach lover's paradise, with perennially pleasant weather and great surf. You might think of a military town, home to *Top Gun*, Navy, Marine, and Coast Guard hubs. Maybe you know San Diego as one of the country's leading technology centers, on par with Silicon Valley and Boston.

All these are indeed threads that makeup San Diego's history. In the city, there is perhaps only one place where they all converge: Scripps Institution of Oceanography.

Scripps Institution of Oceanography at the University of California San Diego, still referred to by many on campus and around the science community as "SIO," is a hub of world-changing science and the place where the modern era of climate change research originated. It is the first institution in the United States to accommodate the full breadth of oceanography as the term is defined today. Its history parallels the history of San Diego since the beginning of the 20th century. From it came UC San Diego, and from that university came a thriving community of high-tech firms such as Qualcomm, Illumina, and the Naval Information Warfare Systems Command (NAVWARSYSCOM).

Scripps Oceanography was founded in 1903 and began its existence as a marine biology station, a distant outpost of the University of California in Berkeley, thanks to the vision of a founding scientist, dedicated philanthropists, and a core group of city leaders who saw the institution as a way to put San Diego on the map.

The story begins with the summer visits of William Ritter, a zoologist who joined the faculty of the University of California in 1891. He immediately took up a search for locations along the California coast to study marine biology, a branch of science he considered woefully under-investigated. In his search for a station, he eliminated out of hand San Francisco Bay because the rough waters there made small boat operations treacherous. He considered San Pedro in Los Angeles, renting a small laboratory there and conducting six-week undergraduate summer courses in 1901 and 1902, but the burgeoning port there made him think a research station would not be a good fit amid what would soon become a collection of mammoth commercial shipping operations.

One of the sampling sites visited by the research vessel hired by Ritter's team was in San Diego. Ritter's colleague Charles Kofoid had returned from a 1901 trip enthusiastic about the biology to be studied there. While Kofoid was in the city, he became acquainted with prominent San Diego physician Fred Baker, an avid malacologist who collected marine and freshwater snails. Baker urged Kofoid to consider San Diego as the best location for the station Ritter envisioned. From fellow civic leaders, Baker marshaled a guarantee to provide Ritter with funds to cover the costs of work at sea beginning in the summer of 1903.

The station was to be an extension of the University of California, but because of its remoteness from Berkeley, it was necessary to create a local entity to administer it. In the fall of 1903, the Marine Biological Association of San Diego came into existence with Ritter as its scientific director.

The first home of the association was the boathouse of the famous Hotel del Coronado in San Diego Bay. But the creatures of the bay were significantly unlike those to be found in the open ocean, and the small vessel the association had rented took two hours to get from Coronado to where Ritter considered suitable waters for sampling. By 1905, the neighborhood of La Jolla, 15 miles to the north, a place "in most ways unsurpassed in natural charm by any on the California coast," according to Ritter, had emerged as a better place for a permanent station.

With Baker's help, $1,000 was raised to construct the first laboratory at La Jolla Cove in 1905. In keeping with the association's charter, still observed to this day, a portion of the laboratory was reserved for an aquarium open to the public.

Though Baker was an initial catalyst, Ellen Browning Scripps and her half-brother, the newspaper magnate E.W. Scripps, soon emerged as the most significant benefactors of the small outpost. Visitors to San Diego will recognize the Scripps name throughout the city. Besides Scripps Oceanography, Scripps Hospital, the Scripps Research Institute, and Scripps Ranch, a section of town built on the ranch owned by E.W. Scripps in the early 1900s, all owe their existence to these philanthropists.

The building at La Jolla Cove known as the "little green laboratory" was never meant to be a permanent home for the biological association, and soon, Ellen Browning Scripps identified a 170-acre oceanfront tract located on ancient Kumeyaay land on La Jolla Shores as a potential permanent home for the laboratory. With Ellen and E.W.'s influence, the City of San Diego granted it to the association at a special auction for $1,000. No other bidders had appeared. Ellen Browning Scripps had secured the arrangement by agreeing to put up $10,000 to fund a public road to access the new research center.

The largesse of the Scripps siblings did not end there. In 1905, Ellen Browning Scripps announced her intention to put $50,000 at the association's disposal. The first expenditure was for the construction of the George H. Scripps building, named for her late brother. The two-story building was designed by noted local architect Irving Gill and completed in 1910. She also funded the institution's first research vessel, *Alexander Agassiz*, put into service in 1907 and named for the famous Harvard biologist who had visited the station in 1905.

More building ensued. The first residence on the parcel, today nicknamed the "Old Director's House," was completed in 1913, based on blueprints created by Ritter's wife, Mary E. Ritter, a pioneering physician and advocate of women's rights seen by many as one of the unsung heroes responsible for the birth of the institution.

In 1915, Ellen Browning Scripps funded the institution's first pier, 1,000 feet long and made of wood and concrete. The new structure was dedicated on August 9, 1916, with a speech by University of California president Benjamin Wheeler and three-legged races by adults and children alike. Two weeks later, a researcher walked to the end of the pier and took a seawater sample and temperature reading. Ever since, that reading has been repeated daily, creating one of the oldest continuous records of ocean conditions in the world.

This La Jolla campus was the property of the biological association but had no affiliation with any university, besides the faculty positions of Ritter and other staff at Berkeley. It could not go on indefinitely subsisting on the generosity of the Scripps siblings. Ritter and Kofoid—by then the chair of the zoology department at Berkeley—made their case to the University of California to take over the property. In July 1912, its transfer from the association to the University of California Board of Regents became official at the beginning of the fiscal year, and its name became "Scripps Institution for Biological Research." For the next several decades, any student who earned his or her PhD at Scripps Oceanography received their diploma from UC Berkeley.

The scope of the station's research expanded in the 1910s. New researchers were recruited to delve into ocean physics, marine biochemistry, and geology. Early attempts at weather forecasting were made. World War I made the timing of this fortuitous. By war's end, the US government, more consumed than before with considerations of the economic and strategic importance of the oceans, sought out research centers that specialized in the study of the great global commons. The term "oceanography" had only been in existence for two decades when Scripps was founded.

Twenty years after the biological association was formed, Scripps was already seen as a leader in Pacific Ocean studies, and its relationship with the federal government, particularly the US Navy, was cemented. When Ritter retired in 1923, it was widely acknowledged that his successor's first task would be to develop America's first oceanographic institution, going beyond the study of regional marine biology.

Ritter's successor, the geologist T. Wayland Vaughan, had ample connections with federal science agencies in Washington, DC. Scripps Institution for Biological Research became Scripps Institution of Oceanography in 1925 to reflect its widening aspirations. Its research expanded to include the entire Pacific Ocean. US Navy vessels helped Scripps collect data along the West Coast. Thermographs making automatic ocean temperature measurements became standard equipment on ships operated by the Navy, the US Coast and Geodetic Survey, and even some commercial ocean liners. Scripps Oceanography awarded the first oceanography degree in the United States in 1930, and that same year, Vaughan consulted on the creation of America's second oceanographic center, the Woods Hole Oceanographic Institution in Woods Hole, Massachusetts. Ritter Hall, Scripps's second building, was designed by Louis Gill, nephew of the architect of the George W. Scripps building, and opened in 1931.

Despite the impressive growth during Vaughan's tenure, Scripps Oceanography's actual forays into the farther ocean were rare. Scripps had been without a ship of its own since 1917, when it sold *Alexander Agassiz*. It did not acquire a new one, R/V *Scripps*, until 1925. Part of the problem was that few of Vaughan's faculty members were interested in conducting research on the open ocean, since many of their studies were done on land or close to shore. An ailing Vaughan himself could not take Scripps to the next level and, in acknowledging that, retired in 1932, hoping a successor could.

After years of courting, Scripps Oceanography succeeded in recruiting Norwegian physical oceanographer Harald Sverdrup to take over in 1936. With him came a new generation of young oceanographers eager to explore the world. They included Walter Munk, an Austrian immigrant who came to La Jolla to pursue a romantic interest but ended up falling in love with the town instead. One of Munk's first friends at Scripps was a new postdoctoral researcher named Roger Revelle. Like Munk, he wanted to experience all the oceans had to offer.

World War II and the following years gave Munk and Revelle the opportunity. The new citizen Munk had enlisted in the Army before the war had broken out, but he was quickly called back to Scripps. Sverdrup needed his help to create techniques for measuring surf and swell forecasts. The method they devised and taught to military meteorologists would guide Allied amphibious landings throughout Europe and North Africa, including at Normandy. Meanwhile, other Scripps scientists at the new University of California Division of War Research, based in the San Diego neighborhood of Point Loma, gave the Allies an advantage in submarine warfare, such as by developing underwater acoustic methods for detecting enemy craft.

The war years also saw Scripps Oceanography create the first English-language comprehensive textbook of oceanography. *The Oceans: Their Physics, Chemistry, and General Biology*, completed in 1942, was considered such a wartime asset that the US government restricted its distribution to America and Canada in its first year of publication.

Like World War I, World War II produced a postwar boom in oceanography. The Navy needed oceanographers, and Scripps was the only place in the country conferring oceanography doctoral degrees. The symbiosis helped Scripps to build a research fleet using surplus Navy ships. The golden age of Scripps exploration was about to begin.

The institution's mission transitioned from one of wartime national security to one more rooted in basic science, aided by funding from a new government agency, the National Science Foundation. The postwar period saw Scripps Oceanography scientists traverse the Pacific Ocean to understand fundamental physics, try new methods such as using scuba gear on research dives, lay groundwork for modern plate tectonics theory, and conduct regular surveys of California marine life and the physical and chemical conditions of their habitats through the groundbreaking CalCOFI (California Cooperative Fisheries Investigations) program. Scripps Oceanography researchers

created the field of coastal oceanography, established the first guidelines for safe research diving, and invented perhaps the oddest-looking marine research craft in history, the Floating Instrument Platform, or FLIP. Six decades after its construction, FLIP remains the only oceanographic tool of its kind, enabling physical oceanographic research never before possible.

Sometimes overlooked in favor of research centers closer to the halls of power on America's East Coast, Scripps Oceanography nonetheless came into its own as an international science leader in this period. Roger Revelle became Scripps's director in 1950 and continued to be an active researcher. He would make a statement in a 1957 research paper that would become one of the most prescient in the history of science. In a review of carbon dioxide levels in the atmosphere and oceans, he and coauthor Hans Suess concluded that "human beings are now carrying out a large-scale geophysical experiment of a kind that could not have happened in the past nor be reproduced in the future." The two were referring to the use of fossil fuels in vehicles and industry. The "experiment" would later be dubbed global warming.

Around the same time, Revelle recruited a geophysicist, Charles David Keeling, who had created a technique for making precise measurements of carbon dioxide (CO_2) in the air. Keeling set about to measure CO_2 levels around the world, but one station became the effort's icon. The data recorded by instruments atop Hawaii's Mauna Loa were plotted and became known as the Keeling Curve. It was the first continuous record showing a steady increase in greenhouse gas and became the launchpad for the modern era of climate change research.

Today, long-term observations remain a distinguishing feature of research programs at Scripps Oceanography. Besides the Keeling Curve and quarterly CalCOFI surveys, Scripps scientists operate global networks of seismometers to observe deformations of land and improve the prediction of seismic activity. They monitor coral reefs and marine protected areas over time to understand their ability to remain resilient in the face of human encroachment. Scripps oceanographers invented a robotic float network to measure salinity and temperature that are now deployed in every ocean of the world. This network, known as Argo, gives scientists a way to "see" all the oceans at the same time in a way never before possible. The data are transforming how the world understands its great global commons, and the record only gets more valuable with time.

Well into its second century, Scripps Oceanography now pursues a mission to understand the natural world and protect it. It does so by applying science to issues of societal relevance and understanding the value, monetary and otherwise, of thriving natural systems. The new generations of research centers that it established are now joined in the mission as a new century of dramatic upheaval in nature unfolds.

One

"A Laboratory Capable of Great Things"

San Diego, California, had a population of 17,700 people in 1900, half the size of Allentown, Pennsylvania, at the time. It might not have seemed a strong candidate to become home to the place now known as Scripps Institution of Oceanography three years later, but because a small group of people in possession of individual ambitions and vision became connected to each other at the right time, a place of global significance came into being.

The players included William Ritter, a biologist looking for a place in California to explore the ocean; his wife, Mary Ritter; William's colleague Charles Kofoid, who fell in love with San Diego as a launch point for ocean studies; and Fred Baker, a physician, city father, and amateur naturalist who stoked Kofoid and Ritter's enthusiasm.

Then there is the institution's namesake family: the Scrippses. Ellen Browning Scripps was the enthusiastic La Jolla resident determined to help the tiny institution grow. Together with her half-brother, newspaper magnate E.W. Scripps, she had the resources to nurture its transition from a rented room to a place too big to be ignored when the University of California acquired Scripps in 1912. The institution today is just one of several San Diego entities that owe their existence to these siblings and their descendants.

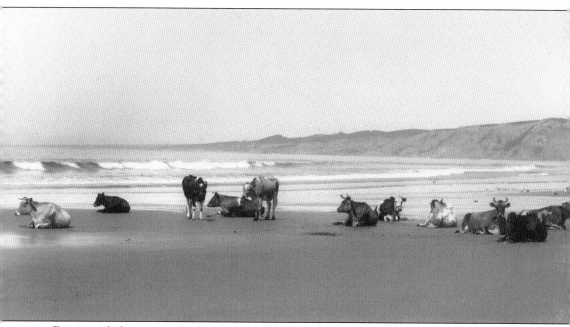

Dairy cattle lounge on the beach south of the future site of Scripps Institution for Biological Research in 1906. The beach would later become known as La Jolla Shores and the institution as Scripps Institution of Oceanography. At one point in 1909, Scripps Oceanography's first director complained to the neighboring dairyman that his cows were not only trampling newly planted trees but also regularly entering the first building on campus. The La Jolla neighborhood of San Diego had been developed as a resort area that featured a bathhouse and a tent city that sprang up every summer. On the other side of the cove, however, the land was undeveloped until 1907, when the Marine Biological Association of San Diego purchased a 170-acre parcel for $1,000 and set the city's identity as a hub of science in motion.

The architects of what would become Scripps Institution of Oceanography were led by William Ritter, a University of California marine biologist who sought a station on the coast suitable for field research. Of Ritter's creation, an early booster later said, "Few institutions of this character have grown up which more fully express the ideas and ideals of one man than does this one."

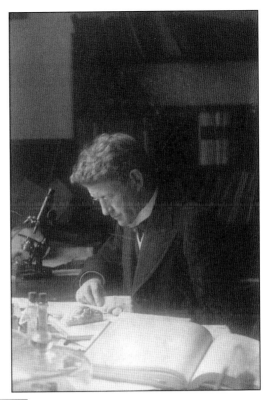

Physician Mary Bennett and William Ritter were wed in 1891, the year Ritter became an instructor in biology at Berkeley. Among Mary's many accomplishments related to the birth of Scripps Oceanography was her fortuitous introduction of her husband to Fred and Charlotte Baker. Fred, whose passions included collecting seashells, was the first booster to promote the idea of a marine research center.

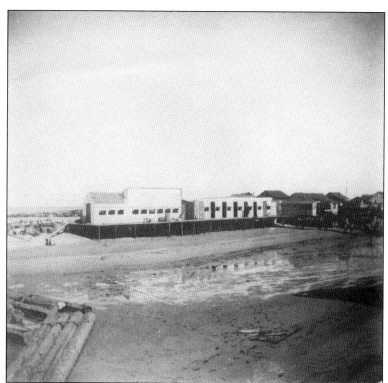

Ritter rented lab space at San Pedro harbor starting in 1901. Quickly, however, he had decided that the bustling port would not be suitable in the long term. "This realization was disquieting not from any hostility to commercial development, but from a prevision of the inevitable destruction of some of the best collecting grounds in and about the harbor," he would later write.

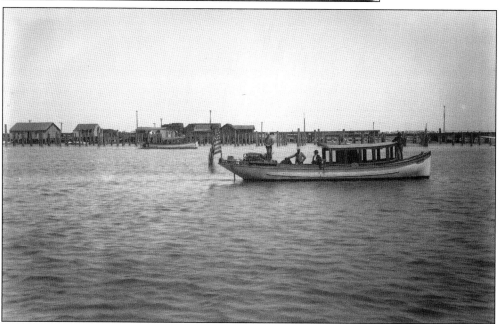

Ritter rented the *Elsie* for use in the summer of 1901. The boat, commanded by Ritter's colleague zoologist Charles Kofoid, collected specimens and made measurements at 40 locations over three months. Remembering San Diego with fondness, Ritter suggested Kofoid make a port call there and contact his friend Fred Baker. It was this trip that converted Kofoid to the notion of San Diego becoming the location of the biological station.

Fred Baker, a local physician, had met William and Mary Bennett Ritter during the Ritters' 1891 honeymoon in San Diego. A decade later, Kofoid, at Baker's urging, addressed civic and business leaders, speaking of an envisioned biological station to rival the greatest in the world. Baker worked to sell Kofoid and Ritter on San Diego and the city fathers on the two scientists' ambition.

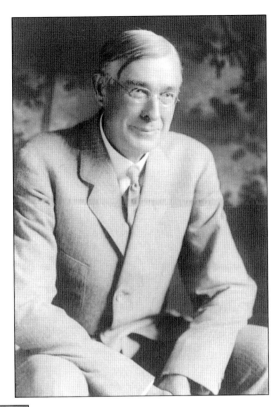

Kofoid, seen here in an undated portrait, played a key role in situating the future Scripps Institution of Oceanography in San Diego. His research specialty was planktonic protozoans. After joining the University of California in 1900, he became involved in William Ritter's effort to establish a marine biology station on the California coast.

Ellen Browning Scripps, with her half-brother Edward Willis, became the chief benefactors of the Marine Biological Association. "Although a considerable number of citizens of San Diego contributed well during the first two years, these two persons were the chief givers and soon became the exclusive patrons so far as money gifts were concerned," Ritter would write in a 1912 report.

Media mogul E.W. Scripps had moved to San Diego to be closer to half-sister Ellen and in search of relief for his allergies in the region's warm, dry climate. E.W.'s first contact with the association came when Fred Baker solicited a pledge of $500 from him in the spring of 1903. The hard-charging E.W. would become a confidant of the soft-spoken William Ritter in the early years of the institution.

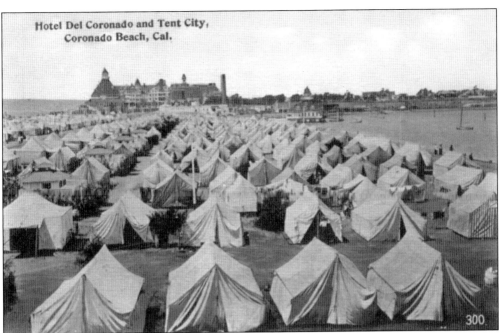

The Coronado Beach Company offered the University of California the use of the boathouse of the Hotel del Coronado as an initial home for the association's first laboratory. Researchers lived in "Tent City," a collection of tents for vacationers that could be rented for 50¢ a day. Despite the distractions offered by its carnival-like atmosphere, the researchers reported good progress with studies of local marine life at the end of summer in 1903.

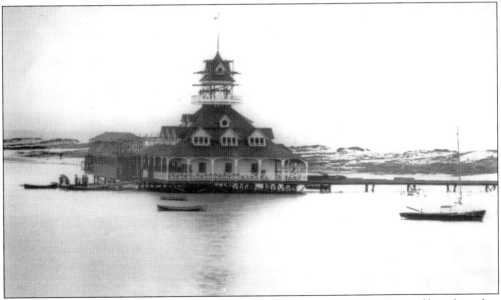

The boathouse proved a good location for the first laboratory in terms of ease of boat launches and readily available seawater samples, but Ritter soon decided that the fauna to be found in the immediate vicinity of the boathouse were considerably different from those to be found in the open ocean. The shaky boathouse structure also made certain activities like microscopy exceedingly difficult.

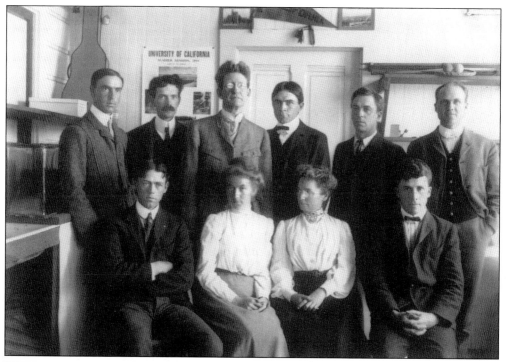

Association staff assembled for a group photograph at the hotel boathouse in 1903. Seated from left to right are (first row) John Bovard, Effie Rigden Michener, Alice Robertston, and Calvin Esterly; (second row) Robert Williams, B.D. Billinghurst, William Ritter, Loye Holmes Miller, Charles Kofoid, and Harry Torrey.

Members of the crew and scientific members assemble on the US Fish Commission steamer *Albatross* during the 1904 Albatross Expedition. Third from right is Alexander Agassiz, a famed specialist in marine ichtyology who became the namesake of the first Scripps research vessel. At the far right is Charles Kofoid.

Two men believed to be Kofoid and oceanographer Henry Bryant Bigelow pose next to a Sigsbee sounding machine aboard the steamer *Albatross*. The machine used wire rope to take ocean depth soundings. The association was allowed part-time use of the vessel to conduct a survey of conditions off the Southern California coast. Ritter hoped the cruise would help establish a body of scientific literature on the young association's initial area of study and attract interest from the research community.

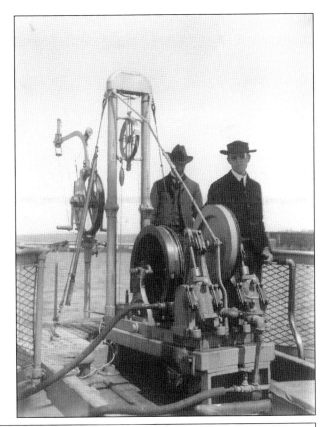

Ellen Browning Scripps had come to know William Ritter through her half-brother E.W. and soon became an enthusiastic advocate. She attended weekly lectures in La Jolla given by Ritter and Kofoid out of a desire to communicate their science to the general public. In 1906, She pledged $50,000 to be used as an endowment to the new biological association. In today's dollars, that amount would be more than $1.3 million.

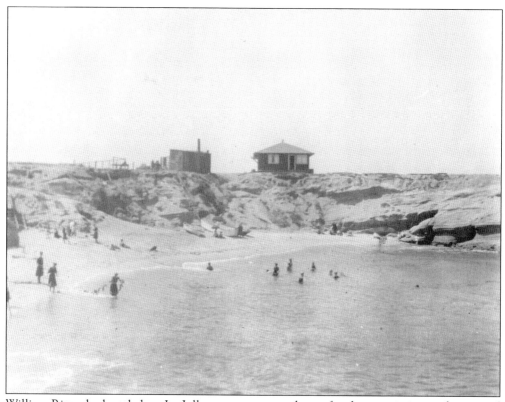

William Ritter had settled on La Jolla as a permanent home for the association and proposed construction of a two-story edifice. The building, as mocked up by University of California architects, had a construction cost estimate of $50,000. E.W. Scripps wanted something that could be operational quickly. The La Jolla Improvement Society raised $1,000 to build what would become known as "the little green laboratory." The final price of the building was $992.

All parties understood that what Ritter called the "sardine-like condition of things" in the laboratory—the dimensions of which were 60 feet by 24 feet—would be temporary. Even with its small size, the building lived up to the association's charter and provided an aquarium open to the public within its walls. It also housed three laboratories and a reagent room.

Myrtle Johnson conducts research in the temporary La Jolla laboratory sometime between 1905 and 1907. Johnson was a zoologist; a teacher of biology at Pasadena High School in Pasadena, California; and one of the association's first staff members. A former graduate student of William Ritter, Johnson would go on to write the influential marine life study "Seashore Animals of the Pacific Coast" in 1927.

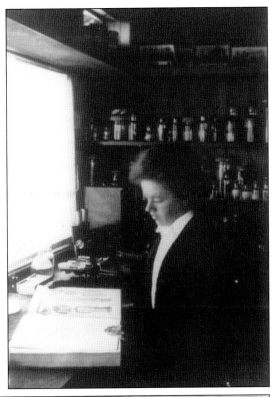

E.W. Scripps gave the association the use of his yacht, the *Loma*, in 1904 and paid to have it fitted with a gasoline engine and scientific instruments. Various retrofit delays meant the vessel was not ready for use, late and over budget, until the following summer. After all that, the vessel was destroyed in July 1906 when it ran aground at San Diego's Point Loma.

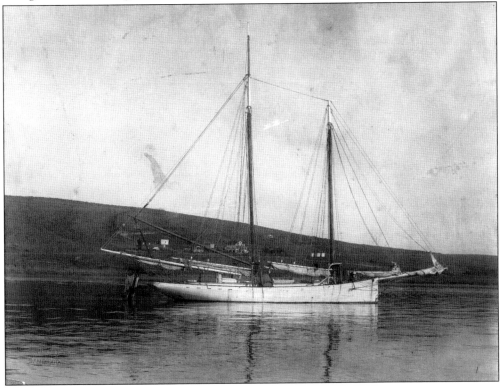

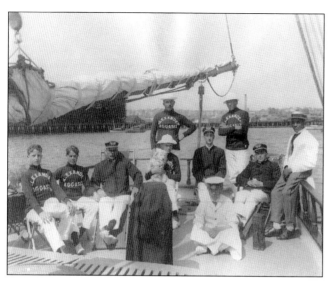

Undaunted by a misspelled name on their uniforms, E.W. Scripps's son Robert and friends gathered for a cruise on research vessel *Alexander Agassiz* in this undated photograph. In 1907, the ketch became the first vessel owned and operated by the Marine Biological Association and the first built specifically to conduct oceanographic research. Ellen Browning Scripps, who donated the funds for the vessel, opted to name it after the Harvard oceanographer who had visited the fledgling campus in 1905.

The George H. Scripps building was designed by noted San Diego architect Irving Gill and completed in 1910. The building housed a classroom, laboratory space, a library, living space for William and Mary Ritter, and a public aquarium. The building, restored and designated as a historical landmark, is now used by Scripps Oceanography administrative staff, and the classroom and library are used as meeting spaces.

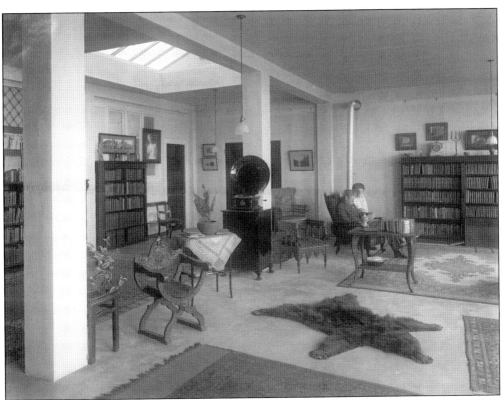

William and Mary Ritter made a portion of the second floor of the George H. Scripps building their first living quarters. By this time, Ritter would maintain his tie to the University of California by returning to Berkeley for a few months in spring to give a short course of lectures. By the time he returned in 1910, the building was ready for occupancy.

Wesley Crandall takes a seat on the steps of the little green laboratory in 1905. Crandall became the institution's business manager in 1913 but by then had already served as the captain of R/V *Alexander Agassiz* and the biological association's secretary. Toward the end of Ritter's tenure as director, Crandall took on an increasing number of administrative duties, as Ritter was frequently away from campus on business.

Research assistants Myrtle Johnson (left) and Edna Watson Bailey lived on campus with the Ritters. Though most staff lived in the nearby La Jolla village, the road around La Jolla Cove was deemed too treacherous for the women to have to walk every day. It is unclear why they are carrying rifles in this photograph taken around 1910. Most of the biologists were loath to kill any of the local wild animals.

The George H. Scripps building was flanked by a garage and a tower, from which seawater flowed into the building's labs. The two figures just visible in this 1910 photograph are identified as William Ritter, standing in the doorway of the new building, as his wife, Mary, approaches in a car.

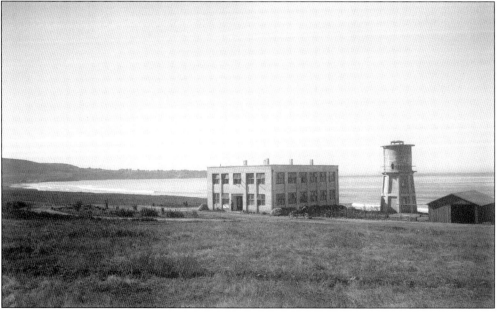

Francis Sumner, seen here in a 1936 portrait, served as director of the US Bureau of Fisheries Laboratory at Woods Hole, Massachusetts, and then as a naturalist on research vessel *Albatross*. Sumner was among the first wave of scientists who became interested in joining the new institution in La Jolla and did so in 1913. An auditorium on campus is named for him.

A two-story bungalow built for Scripps director William Ritter and his family was completed in 1913 at a cost of $4,000. A legend persists that the house was based on plans for the Ritters' home that was to be built for them by their famous friend, the architect Julia Morgan, when they lived in Berkeley, California. Mary Ritter later said in her autobiography, however, that she discarded the plans once they decided to move to La Jolla.

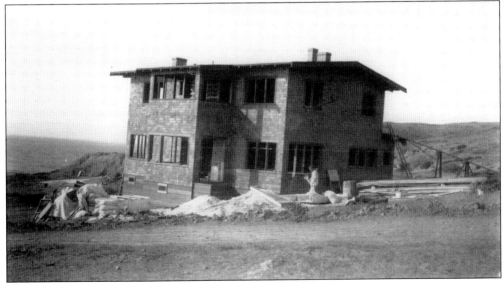

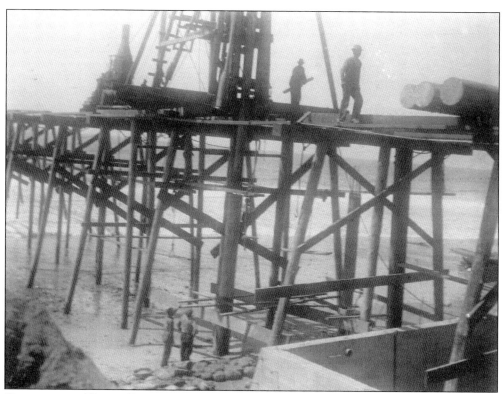

Construction of Scripps Pier was approved in 1913, delayed somewhat by the onset of World War I, and finally commenced in the spring of 1915. The Los Angeles–based contractor Mercereau Bridge and Construction Company used horse teams to drag beams to the construction site of the pier. Scripps benefactor Ellen Browning Scripps had initially allotted $34,000 of a $100,000 gift to build the 1,000-foot pier, but the unexpected depth of the water and sand between the surface and the bedrock into which pier pilings needed to be buried ran up the cost. The pier and other new buildings on campus were collectively dedicated on August 9, 1916.

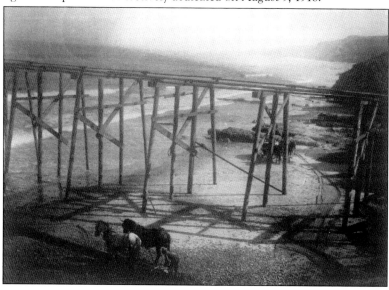

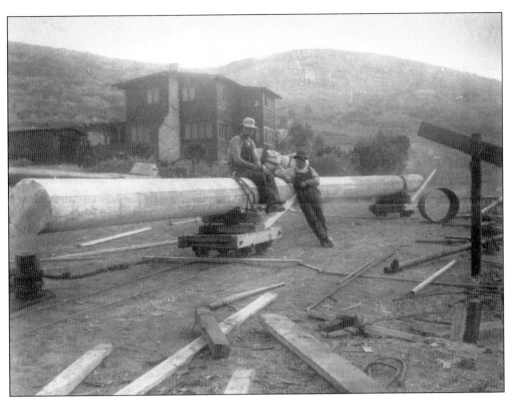

Construction workers take a break on a piling during the building of the pier in 1915. In the background is the director's house.

George McEwen was a Stanford University physicist recruited by Ritter in 1908. McEwen's work was instrumental in taking the biological association beyond its original bounds of research by relating factors like ocean circulation, upwelling, and temperature to the movements of plankton. Seen here in 1935, McEwen would remain at Scripps until 1952.

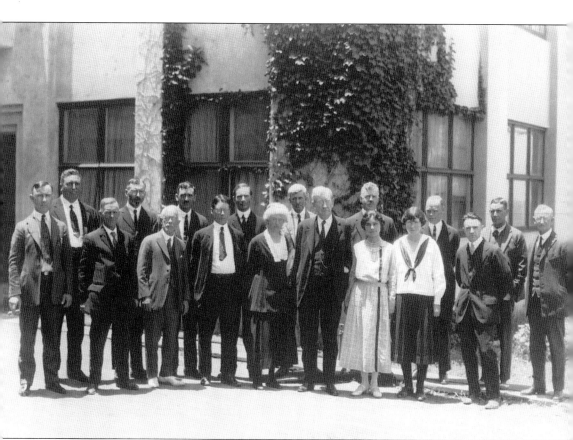

The staff of the Scripps Institution for Biological Research gathered in June 1923 for William Ritter's retirement party. From left to right are (first row) three unidentified men, Percy Barnhart, Myrtle Johnson, William Ritter, Tillie Genter, Maurine Leslie, and Ralph Huestis; (second row) Jack Ross, Francis Sumner, Jim Ross, George Francis McEwen, Winfred Emory Allen, Wesley C. Crandall, Erik Gustaf Moberg, and two unidentified people. In his final years, Ritter was frequently away from campus as its profile as a national research resource rose. He spent his last year looking for his successor, consulting with leading researchers around the country. He knew its identity was about to change considerably. In a letter to a colleague, Ritter wrote that the consensus opinion was that Scripps "ought to be treated as a nucleus for an oceanographic institution worthy of the magnitude of the oceanographic problems of the largest ocean now on earth and one of the richest countries on earth."

Two

The Biological Colony

For a cost of $10, the Marine Biological Association deeded in 1912 its property to the University of California, which christened the campus the Scripps Institution for Biological Research. The first priority thereafter was the creation of a campus, starting with the construction of a dozen cottages for staff housing in 1913. They would remain homes for various faculty and staff and their children until 1959. The "biological colony" was born.

E.W. and Ellen Browning Scripps continued support of the institution until their deaths—with E.W.'s in 1926 and Ellen's in 1932—but new family benefactors such as Robert Paine Scripps filled the void to continue the family's vital philanthropy.

As the physical campus expanded, so too did Scripps's ambitions. The institution awarded its first doctorate (in zoology) to student Henry Collins in 1919 and signaled its new direction with the appointment of T. Wayland Vaughan as Scripps's second director in 1925, the same year its name changed to Scripps Institution of Oceanography. Research moved beyond the biology of coastal waters to encompass ocean physics, geology, and geochemistry.

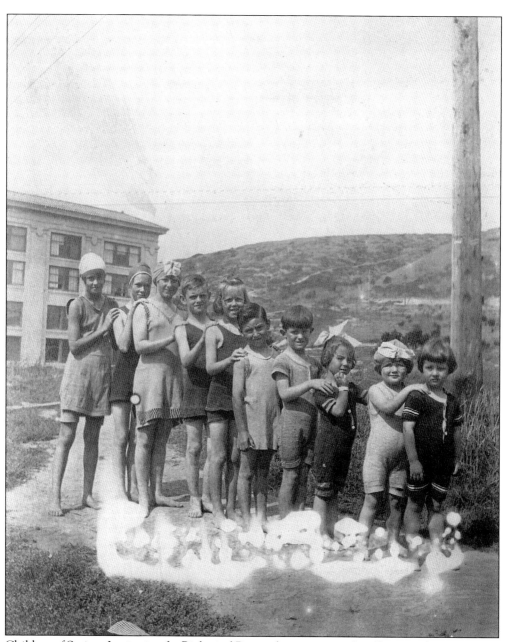

Children of Scripps Institution for Biological Research scientists and staff enjoy a day at "Biology Beach" around 1920. The institution had purchased a Model T in 1913 and offered daily rides into the town of La Jolla for 5¢ per passenger. The frequently muddy road made for arduous walks into town, and for the most part, members of the colony were content to stay home. Families would organize beach parties featuring large pots of clam chowder and celebrated Christmases together. The wife of one staff member created an informal school for the benefit of younger children and, occasionally, Mexican road crew members hoping to improve their English. A local grocer made deliveries that were dropped off in the hall of the George H. Scripps Laboratory. A local desert tortoise that served as an early Scripps mascot would often make off with food before families could collect their parcels.

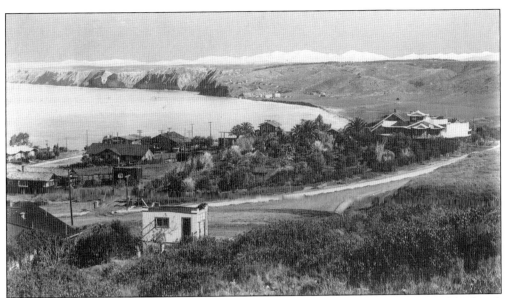

Two views show the development of Scripps Oceanography and its surrounding neighborhood. Above, the Scripps Institution for Biological Research is seen from the village of La Jolla around 1925. Below, an aerial view of the young campus in the same year shows a pier and water tower and a host of new laboratories and residences surrounding the George H. Scripps building. Among the understandings that allowed the Marine Biological Association to acquire 170 acres of beachfront property 18 years earlier was a promise by Ellen Browning Scripps to fund the road that today is known as La Jolla Shores Drive. Traffic on the road that connected Scripps to the rest of the world can be seen at the bottom of the image.

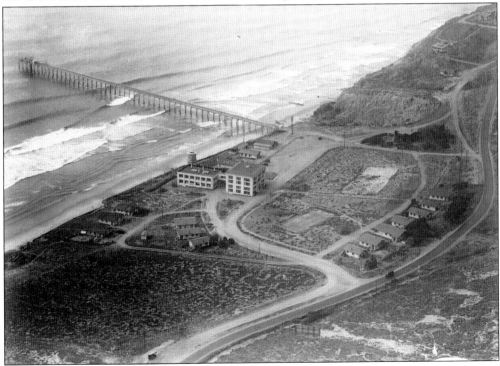

The newness of oceanography itself made several of Scripps's first scientists pioneers in their various fields. Biology professor Winfred Emory Allen, seen here with a collecting bottle around 1926, devised collection method standards involving filtering contents of water samples. He used samples collected at Scripps Pier and elsewhere to draw links between river runoff and plankton growth, among other findings.

Allen joined Scripps Institution for Biological Research as a summer worker in 1917. In 1919, he was tasked with part-time duties such as "publicity secretary," writing news releases about the institution's research findings and submitting reports on the station for local publications, such as the *Federation*, in 1921.

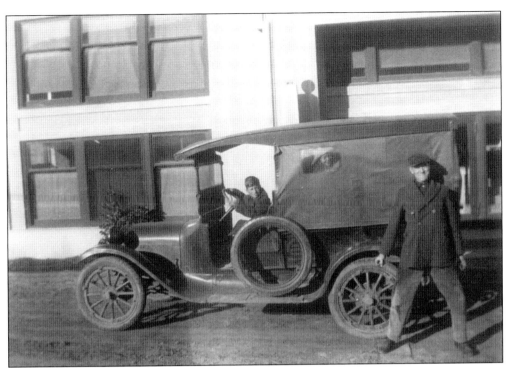

Driver Ralph Taylor poses around 1920 in front of the library-museum building erected in 1916 with the Scripps Institution for Biological Research bus used for mail and groceries. He also drove children of staff—like those seen behind him here—to school each day as the campus grew more connected to the surrounding community.

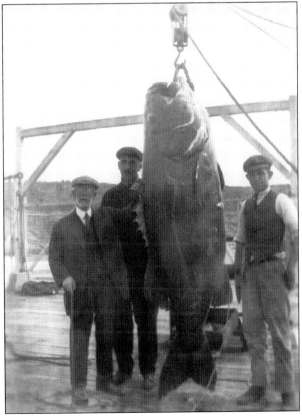

Three unidentified men are seen at Scripps Pier with a giant sea bass catch in this undated photograph. San Diego residents were allowed to fish at Scripps Pier during its first 25 years of existence. The cost was 25¢ a day or $20 for a lifetime permit. Today, public access to the pier is limited, and unauthorized fishing and collection of materials, living or non-living, on either side of it are illegal.

A library-museum building was erected in part to accommodate a flood of new books that overwhelmed the second floor of the George H. Scripps Memorial Marine Biological Laboratory, which connected to it via a pedestrian bridge. Some of the cottages used as residences by staff members and visitors are seen in this 1926 photograph.

Construction of the library-museum was accelerated so that the building could accommodate students in a summer 1916 non-credit course called Assembly in Science. The class was meant for science teachers, but members of the public were invited, in keeping with the institution's mission to make its science accessible to all.

The institution maintained its mandate to provide an aquarium to the public, though it was not always easy to fulfill the mission. Scripps built a new aquarium as part of a spree that included the pier and several outbuildings in the mid-1910s. The new edifice measured 24 by 48 feet. The mess left behind by a February 1932 flood revealed one of the barriers that prevented easy access.

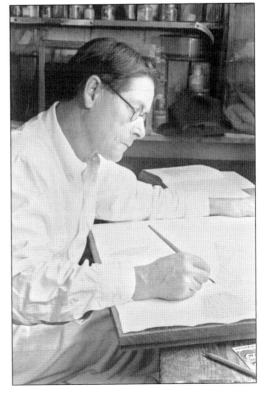

Percy Barnhart was recruited to become the first full-time curator of the Scripps aquarium in 1914 and remained in the position until 1944. Barnhart helped the institution's fundraising efforts by collecting marine life specimens and selling them to scientists. His chief method for acquiring specimens was fishing for them from Scripps Pier.

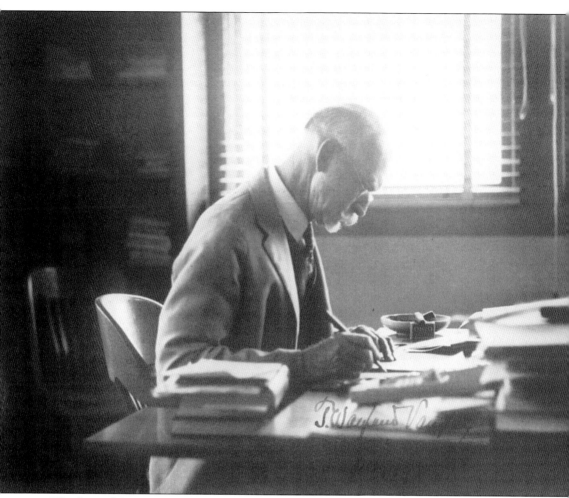

The Second Scripps Oceanography director, T. Wayland Vaughan, was a geologist with ample Washington, DC, connections. Among his conditions for accepting the Scripps directorship, he suggested that research be "extended as rapidly as practicable to chemistry and bacteriology of the sea and marine sediments." Setting the new course to include more studies of the ocean's physics and chemistry was not without controversy. Marine biologists lamented what they viewed as the diminution of their specialty and an abandonment of the association's original core values. Some resigned shortly after his arrival, and others scaled back the scope of their research to stick to projects consistent with the vision of the new director. By this time, the local board of directors that had guided Scripps's expenditures had ceded nearly all control of the institution to the University of California.

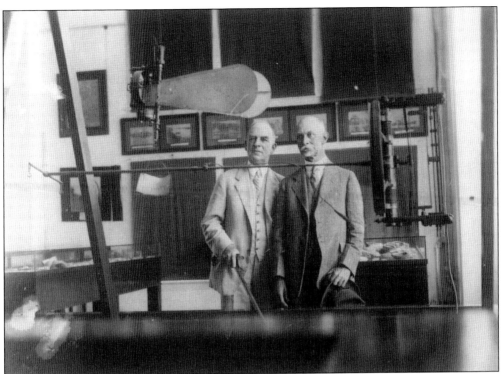

University of California president William Campbell (left) and T. Wayland Vaughan tour the Scripps aquarium in September 1927. Scripps's financial outlook improved considerably thanks to Campbell, who had previously been director of the Lick Observatory near San Jose. His sympathies, formed while operating an entity similar to Scripps, may have been behind his push for the university system and the Scrippses to increase their annual contributions.

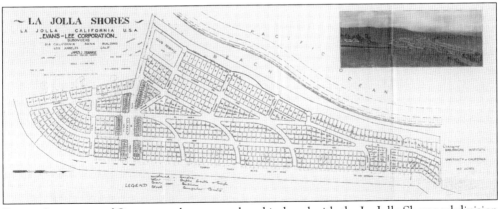

Scripps Institution of Oceanography grew up hand-in-hand with the La Jolla Shores subdivision that bridged the expanse around La Jolla Cove between the institution and the town. Plans drawn in 1929 for the neighborhood show its boundary with Scripps, the name of which was corrected by hand to the name it acquired in 1925. The road identified here as Torrey Pines Boulevard is now called La Jolla Shores Drive.

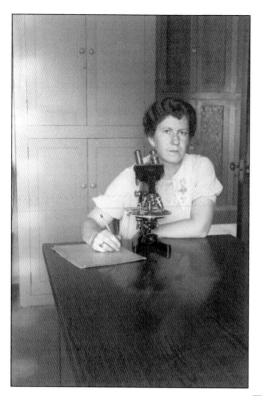

Student Easter Ellen Cupp became the first woman in North America to receive a PhD in oceanography in 1934. Cupp came to Scripps in 1928 and published several research papers on forms of plankton known as diatoms. She continued on at Scripps as a researcher and instructor until 1940.

Student Robert Dietz takes a "seat" aboard the "Queen Mary," a Chevrolet used to haul pier samples, around 1938. Dietz earned his PhD from the University of Illinois but did much of his work at Scripps in marine geology, a field so new he could not immediately find work. After serving in World War II, he remained involved with Scripps as an adjunct professor into the 1960s.

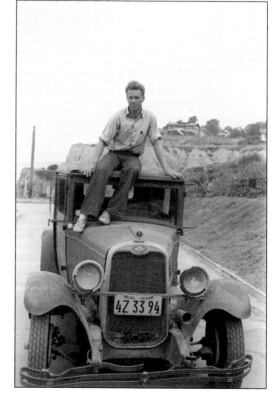

On December 7, 1932, crews demolished the water tower that originally brought seawater to labs on the Scripps Institution of Oceanography campus. Today, pumps deliver nearly one million gallons of seawater to laboratories throughout the Scripps Oceanography campus. Additionally, a tap on campus makes filtered seawater available for commercial and private aquariums.

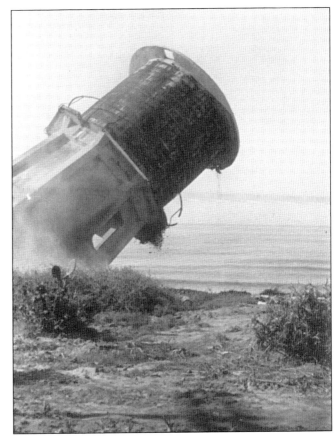

A road sign at the Scripps Institution of Oceanography entrance beckoned motorists to visit its museum and aquarium in this photograph taken in the 1930s. The small aquarium on campus then would give way to a grander one envisioned by curator Percy Barnhart, but it was not built until after his retirement.

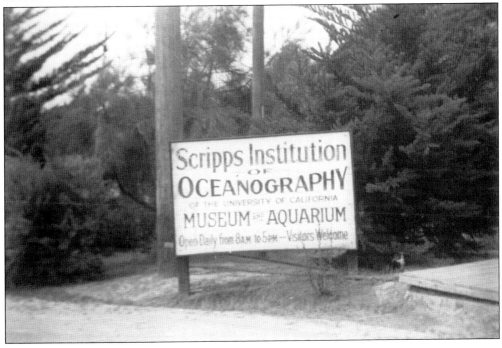

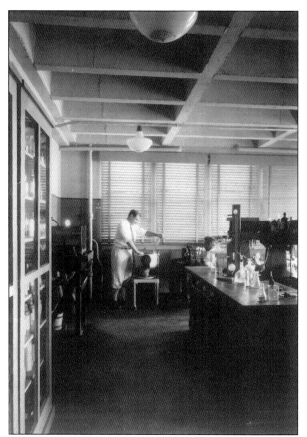

Physiologist Denis Fox is seen here in his Ritter Hall office in 1933. He studied the biochemistry behind pigments produced by marine organisms. In 1954, he famously figured out how to restore the brilliant pink color of flamingos housed at the San Diego Zoo. At his suggestion, keepers added ground lobster shells to their diet, the beta carotene in which was converted into red or pink pigment.

The institution converted a fishing vessel into R/V *Scripps* in 1925. The vessel conducted infrequent cruises off the coast, in part because only one researcher, chemist Erik Moberg, used it on a regular basis. Tragically, R/V *Scripps* exploded at its berth at the San Diego Yacht Club on November 13, 1936, killing its cook and badly injuring its captain.

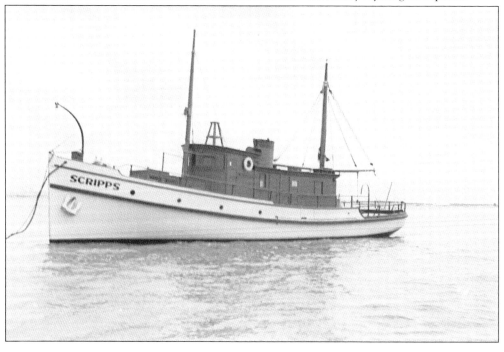

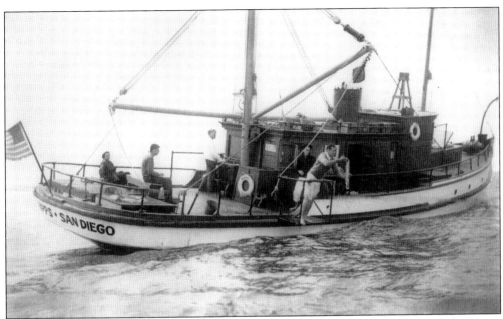

Student Roger Revelle hangs a Nansen bottle to collect a water sample off the side of R/V *Scripps* at an unknown date early in the 1930s. Revelle received his doctorate from Scripps in 1936 and would spend the next 28 years there as a researcher, professor, and finally director, transforming the institution in the process.

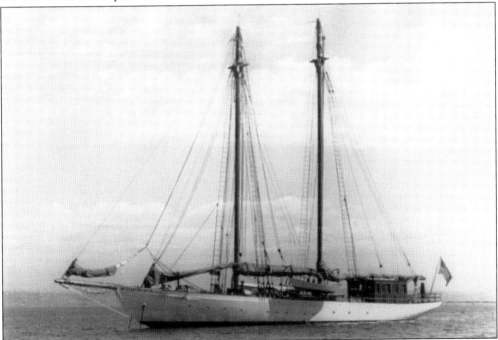

Incoming Scripps director Harald Sverdrup lobbied Robert Paine Scripps, son of E.W. Scripps, to purchase a new research vessel for the institution in 1937. The 104-foot R/V *E.W. Scripps* entered into service in December 1937 after several upgrades were made to it, including the addition of engines that gave it a 2,100-mile cruising radius.

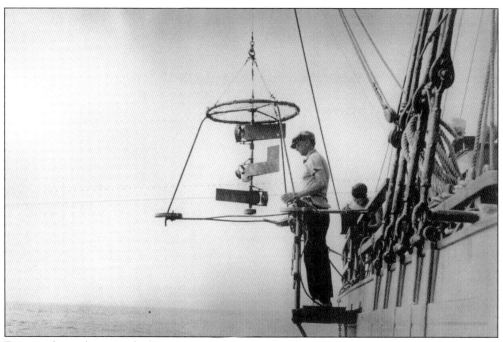

Francis Shepard is seen deploying a current meter off the deck of R/V E.W. Scripps in August 1939. Known as the father of marine geology, he was a sedimentologist who specialized in studies of submarine canyons, such as the Scripps and La Jolla Canyons on either side of the Scripps campus, and the processes that created continental shelves.

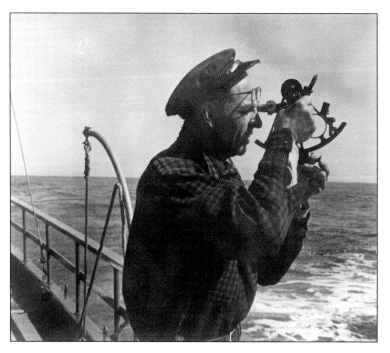

Well before the advent of GPS, E.W. Scripps captain Clem Stose "shoots the sun," using a sextant for navigation in 1938. Scripps oceanographers used the vessel extensively between 1938 and 1941, when the US Navy borrowed the vessel for the newly formed University of California Division of War Research.

Crew members play chess on board R/V *E.W. Scripps* during the first of two expeditions to the Gulf of California in 1939. The two cruises were considered the first in a new era of research at Scripps, indicating the institution's desire to have a continuous presence on the seas. The first of the cruises was the first complete survey of the gulf ever undertaken.

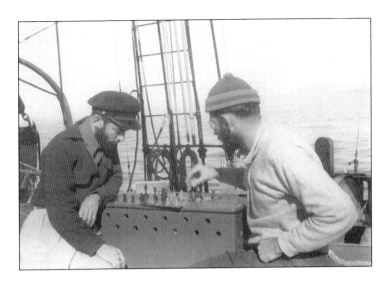

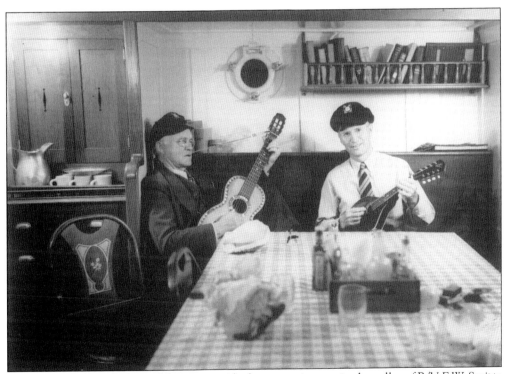

Loye Miller (left) and Martin Johnson provide the entertainment in the galley of R/V *E.W. Scripps* during the first Gulf of California expedition. Miller was a University of California, Los Angeles (UCLA) ornithologist and Johnson a Scripps marine biologist who helped survey the gulf's fauna. Expedition researchers found gulf marine life especially bountiful. They surmised it was because of the strong mixing of the waters that brought deep nutrients to the surface.

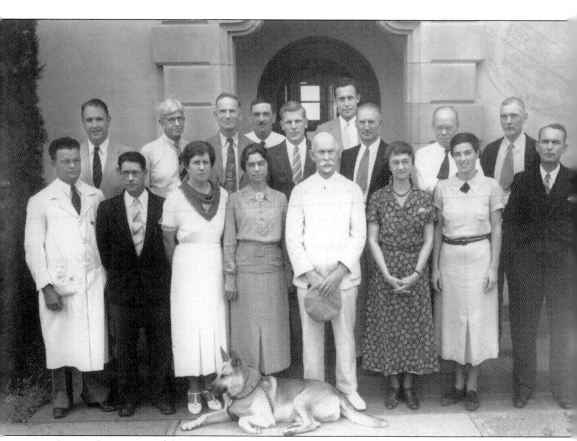

Scripps Institution of Oceanography staff on August 30, 1936, included a mix of veterans from the Marine Biological Association era and new faces who would set the tone for oceanographic research for the remainder of the century. From left to right are (first row) Claude ZoBell, Percy Barnhart, Easter Cupp, Tillie Genter, T. Wayland Vaughan, Ruth Ragan, Ruth McKitrick, and Stanley W. Chambers; (second row) Denis Llewellyn Fox, Winfred Allen, George McEwen, James Ross, Richard Fleming, Roger Revelle, Martin Johnson, Eric Moberg, and Francis Sumner. (The dog's name was Snooks.) Vaughan announced his decision to eventually leave Scripps in 1932, knowing he would not be the right leader to expand the institution's forays into the open ocean. He spent more than a year of his remaining time at Scripps conducting a survey of international oceanography for the National Academy of Sciences. His trip around the world served the secondary purpose of finding his successor.

Tillie Genter was a librarian and administrative assistant who joined Scripps when William Ritter was director. When T. Wayland Vaughan took his extended leave in 1932, chemist Erik Moberg was ostensibly left in charge, but Genter is credited for being the de-facto director while Vaughan was away and then again when Vaughan was laid up by tuberculosis for six months after his return.

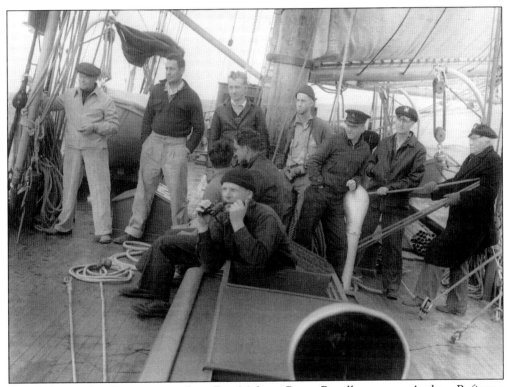

From left to right, Scripps researchers Eric Moberg, Roger Revelle, seaman Andrew Bofinger, researcher Richard Fleming (with binoculars), machinist Bob MacDonald, UCLA botanists George Hale and Lee Haines, engineer Walter Robinson, scientist Martin Johnson, and UCLA researcher Loye Miller survey the horizon en route to the Gulf of California aboard R/V *E.W. Scripps*.

Harald Sverdrup became the third director of Scripps Institution of Oceanography, taking over from Vaughan in September 1936. He was already renowned as a field researcher, having traveled to the Arctic Ocean as a scientific director on the Norwegian research vessel *Maud* on a seven-year voyage beginning in 1918. He disembarked at one point to live with the Chukchi people for eight months and later wrote a book about the experience. Sverdrup's breadth of experience and unparalleled skill in physical oceanography had led Scripps on a long journey of courtship to secure him. He had ambitions to make Scripps a player on the global academic stage but planned to stay as director for no more than five years. The outbreak of World War II in Europe made returning to Norway impossible, so he chose to stay longer. He was then tasked with putting the institution on its own war footing prior to Pearl Harbor.

Three

SCRIPPS GOES TO WAR

World War II changed the trajectory of Scripps Oceanography in nearly every aspect. The enduring symbiosis between the institution and the US Navy had taken shape even before America entered the war, but it was then that Scripps came into its own as a national asset. More than half of its 11 faculty members were on military leave for most of the war, but more significantly, Scripps Oceanography produced science that provided advantages in every theater.

By war's end, the Navy, rather than private supporters or the University of California, would be Scripps Oceanography's chief funding source and the force nurturing new fields of physical oceanography, coastal geology, and marine acoustics. The Navy returned to Scripps the research vessels it had requisitioned for the war and additionally gave it a fleet of former military ships outfitted with the latest technology.

The war also provided to Scripps a cadre of new oceanographers and meteorologists in the form of former military officers, many of whom had been trained by Scripps scientists. They had learned how to forecast surf and swells to guide beach landings and understand marine acoustics to gain the upper hand in submarine warfare. Many enrolled at Scripps immediately after the war to become full-fledged oceanographers.

Just before the war, Scripps had undertaken what would be a landmark endeavor. Director Harald Sverdrup and other scientists had been tasked with writing an oceanography textbook. Their finished product did not teach oceanography so much as define it. It was perhaps the first expression of the holism preached by Sverdrup that allowed for biology, physics, chemistry, and geology to be united in one academic discipline.

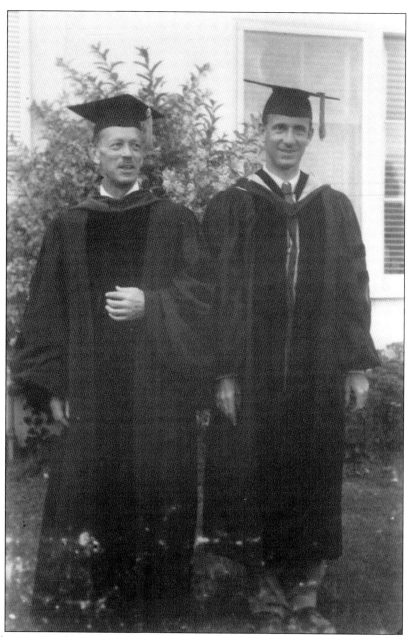

Scripps director Harald Sverdrup of Norway and student Walter Munk of Austria both came from countries occupied by Nazi Germany and would use their intellect to help defeat it. Sverdrup had hoped to step down from the directorship before the war but, having no options for research in his home country, requested to stay on in 1940. Munk had first come to the United States in 1932 and announced his intent to become a citizen in 1936. His family members fled Austria shortly after the Anschluss, and in June 1939, Munk finally received his citizenship papers. Three weeks after that, he enrolled as a student at Scripps Oceanography. Though both provided contributions of incalculable value to the war effort, both would also find themselves under suspicion of being Nazi sympathizers because of their nationalities and were denied security clearances during World War II.

Roger Revelle became a Naval Reserve officer, rationalizing that it might be a better way to go about getting access to seagoing vessels for research if he were in a position to give orders rather than be an observer on Navy ships. In the summer of 1941, he trained as a sonar officer and was assigned to the Navy Radio and Sound Laboratory in the Point Loma neighborhood of San Diego.

The University of California Division of War Research (UCDWR) was created in April 1941 and, at first, shared a building with the US Navy Radio and Sound Laboratory. Later, it would move to a Point Loma mansion dubbed Building X. By the time this 1945 group photograph of UCDWR staff members was taken, the entity employed more than 600 people, mostly civilians and many affiliated with Scripps Oceanography.

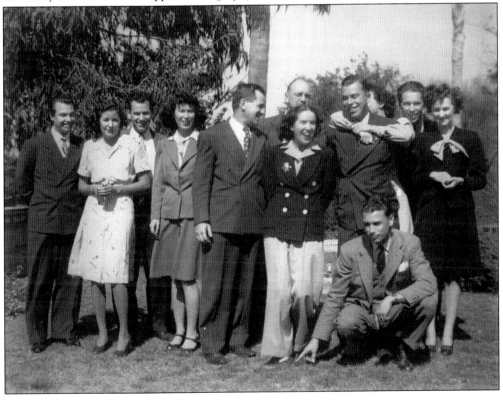

Future Scripps oceanographer Douglas Inman is seen here as a young Marine. Inman would later joke that his harrowing experiences during amphibious landings in the Pacific islands were the beginning of his expertise on beaches and coastal studies. Inman transferred immediately after the war from Caltech when he learned Scripps Oceanography was offering a curriculum in oceanography. (Courtesy of the Douglas Inman family.)

Future Scripps biologist John McGowan is seen as a young sailor in 1944. As a USS *Topeka* crew member, he was in Japanese waters when representatives of Emperor Hirohito signed the instrument of surrender in Tokyo Bay in September 1945. Eight years later, McGowan was among scientists invited to Hirohito's palace during the Trans-Pacific Expedition, the first American oceanographic expedition to Japan since the war. (Courtesy of the John McGowan family.)

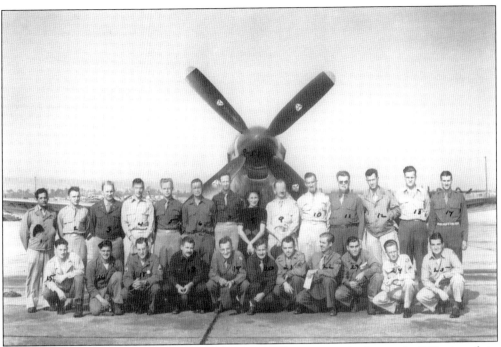

The Physical Testing Section of the US Army Air Forces poses in front of a P-51 aircraft in November 1945. Per Scholander is in the center of this photograph, labeled as "9." Scholander, a captain in the Army Air Forces, improved pilot safety at high altitudes and survival skills in polar seas. The namesake of Scripps's Scholander Hall, he would join Scripps Oceanography in 1958 and establish the Physiological Research Laboratory in 1963.

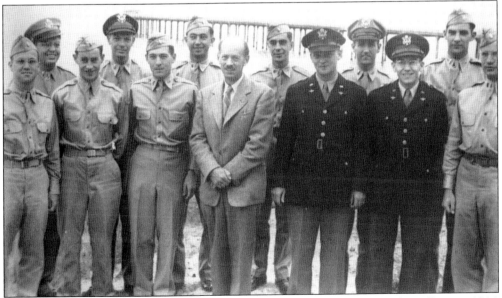

Scripps director Harald Sverdrup poses with a group of Army Air Forces weather officers in 1944. Sverdrup had begun classes in surf and swell forecasting the year prior. More than 200 US and British weather officers took the course during the war. Some would go on to make forecasts used for the D-Day invasion.

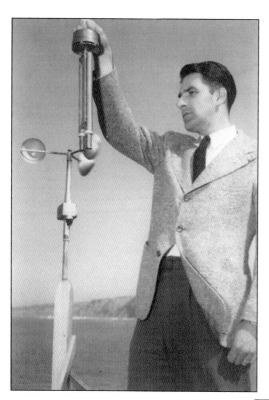

Among Sverdrup's trainees was Dale Leipper, seen here with an anemometer and aspirating thermometer in 1946. Leipper took courses at UCLA, to which Sverdrup would drive up weekly for lectures. Leipper's later wartime assignments included creating fog forecasts to guide military aircraft landings in Alaska. After getting a degree from Scripps Oceanography after the war, he went on to cofound the oceanography and meteorology department at Texas A&M University in 1949.

In 1942, Harald Sverdrup, Martin Johnson, and Richard Fleming completed *The Oceans*, five years after publisher Prentice Hall first pitched Sverdrup on the idea of writing what would become the first comprehensive textbook of oceanography. Though Sverdrup knew writing the book would be daunting, he and the other authors knew it was necessary since other texts were either too specialized or too outdated.

Martin Johnson, a biologist and doodler, drew this cartoon to depict the frantic writing of The Oceans. Sverdrup's secretary Ruth Ragan is at the typewriter while, from left to right, Richard Fleming, Sverdrup, and student Walter Munk hover behind her. The book aided Scripps's transition from a regional research laboratory to a global authority in its field.

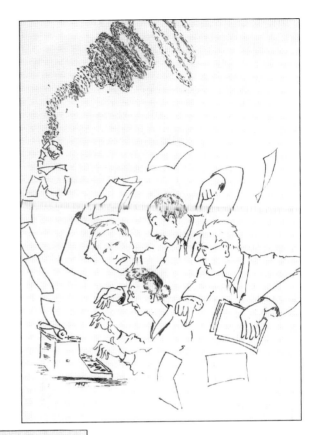

Sverdrup is credited with designing survival charts that were printed on rayon and issued to World War II pilots to be worn as handkerchiefs. If the pilots crashed at sea, the charts were intended to help them aid their own recovery by estimating the paths of currents. The charts reflected the scientific understanding of ocean circulation at the time, but unfortunately, limitations in that understanding often made estimates inaccurate.

A researcher works at a UCDWR lab bench. Physicists and oceanographers there separately experimented with submarine detection methods. By many accounts, the physicists looked down on the oceanographers. The physicists tried visual methods, including high-powered undersea lights. When tests showed those could scarcely illuminate objects beyond 100 feet, the physicists ceded the solution to the oceanographers, who devised more effective acoustic methods. The physicists were reassigned. Their new task became known as the Manhattan Project.

A UCDWR cartoon depicts the challenges of interpreting ocean sounds. In one project, Martin Johnson determined that a loud sound frequently picked up by sonar was of snapping shrimp colonies on the seafloor. US submarines would later use that to their advantage to avoid detection. Scripps oceanographers also identified phenomena like "backscatter," layers of microscopic life in the ocean so concentrated that their presence led to false sonar readings of where the seafloor was.

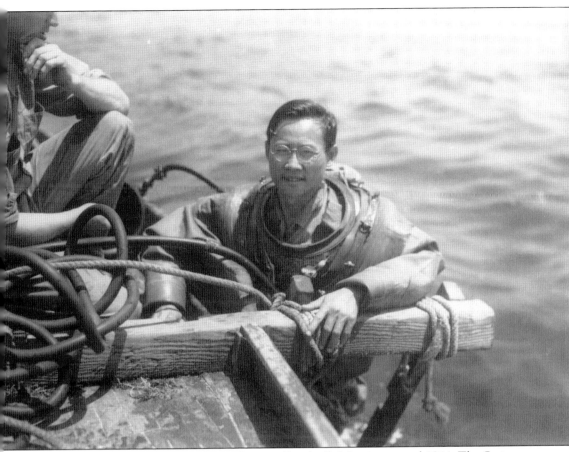

Cheng Kui Tseng prepares for a dive at Laguna Beach, California, around 1944. The Scripps Oceanography postdoctoral researcher is believed to be the first person associated with the institution to dive as part of his research. At the request of US Fish and Wildlife Service scientists, he began in 1942 monthly helmet dives in which he measured specimens of the seaweed Gelidium from which the compound agar can be produced. His work was part of a wartime effort to reduce US dependence on Japan for agar, which is used for culturing bacteria. Tseng had already been an established scholar in China when he came to the United States to pursue a PhD at the University of Michigan. He joined Scripps toward the end of World War II and returned to China in 1946. He is often referred to today as the "father of Chinese oceanography."

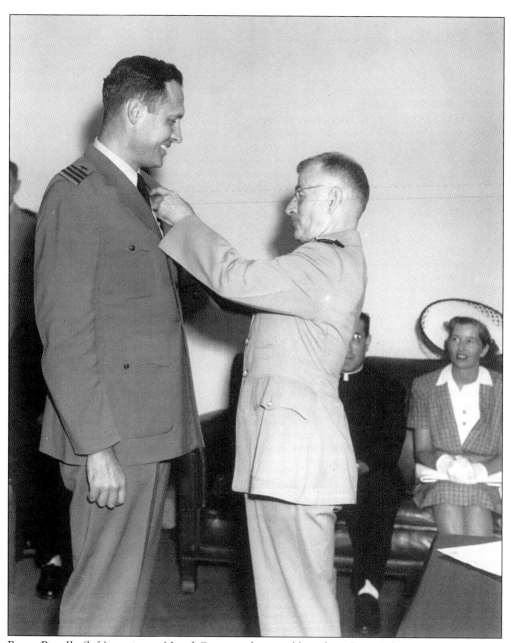

Roger Revelle (left) receives a Naval Commendation ribbon from Rear Adm. Paul E. Lee, chief of the US Office of Naval Research (ONR), while his wife, Ellen Virginia (Clark) Revelle, looks on. Commander Revelle received the award for his work as head of ONR's Oceanography Section during Operation Crossroads, the 1946 atom bomb tests carried out at Bikini Atoll. Revelle had become the head of the oceanographic division of the Navy's Bureau of Ships by 1944 and a full commander by war's end. He fit in well in the Navy while never quite being a military man. He made the case better than any other scientist for why the Navy should invest in oceanographic study, and that legacy would buoy the institution in the postwar years. As Operation Crossroads demonstrated, the war may have ended, but the relationship between Scripps Oceanography and the Navy did not.

Four

THE GOLDEN AGE OF EXPLORATION

In 1946, Scripps Institution of Oceanography remained the only place in the United States offering an advanced degree in oceanography. The UCDWR was disbanded after the war, but from it came a new entity, the Marine Physical Laboratory, a center formed that year that was eventually based at Scripps, where it remains to this day.

Scripps Oceanography was now seen as the logical place in the United States to base inquiries in response to a range of needs for knowledge about the oceans. Those included emerging Cold War intelligence and answers to ocean phenomena that affected California's economy.

This was a new era in which the institution was given free rein to find out fundamental information about the ocean and the natural systems connected with it, regardless of whether the knowledge had immediate practical applications. Historians of science regard this as Scripps Oceanography's golden age of exploration. Nearly any question about the workings of the planet was fair game.

The exploration was not limited to field expeditions. Theoretical scientists, armed with computing power that was rudimentary by today's standards but revolutionary in the postwar years, applied mathematical models to describe what seemed to be hopelessly complex properties of planet Earth. Geophysicists such as George Backus, Freeman Gilbert, and Robert Parker pioneered inverse theory to create models from observational data to determine the relative density and elasticity of materials beneath the planet's crust. Physical oceanographers, including Myrl Hendershott, used mathematics to improve understanding of tides, considering concepts such as how the weight of the oceans deformed Earth's crust.

Within 25 years, Scripps scientists would help launch all-new fields of research pertaining to the oceans, the solid earth, and the atmosphere. Those same scientists would also nurture a new university in La Jolla, though the venture would end in disappointment for the Scripps Oceanography leader who first conceived it.

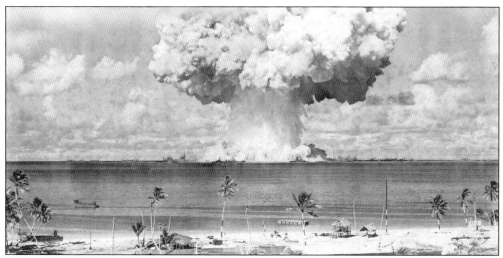

In Operation Crossroads, the US military conducted the first of several atomic bomb tests at Bikini Atoll in the Marshall Islands. Researchers from Scripps were part of a science party of nearly 1,000 people that conducted an oceanographic survey of the atoll's lagoon in March 1946 ahead of the blast and again afterward to understand its physical and ecological effects. Below, Scripps's Roger Revelle, seen here at left with physicist Jeff Holter, led the oceanographic study portion of the test. Holter came up with an ingenious idea, creating a low-tech way to measure the height of waves generated by the bomb. He built a tower made of beer cans with a cover on each can. The height of the highest can filled with water after the wave went out indicated its size. Holter would later join the Institute for Geophysics and Planetary Physics at Scripps Oceanography.

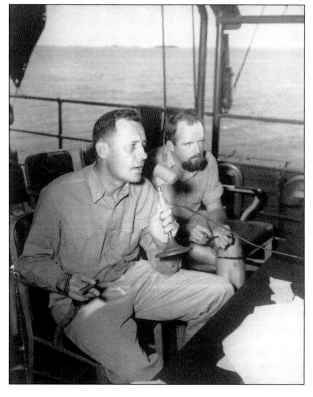

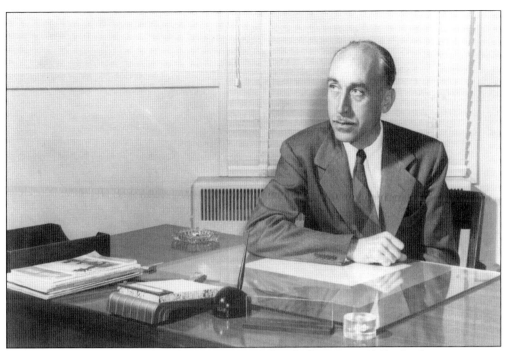

Renowned physicist Carl Eckart became Scripps's fourth director in 1948 after having come to San Diego to join UCDWR. After the war, he became the first director of the Marine Physical Laboratory in 1946, which moved with him to Scripps when he assumed the directorship. He named Roger Revelle as associate director in an attempt to smooth the way for Revelle to be eventually approved by university system leadership as his successor. The plan worked, and Revelle became director in 1950.

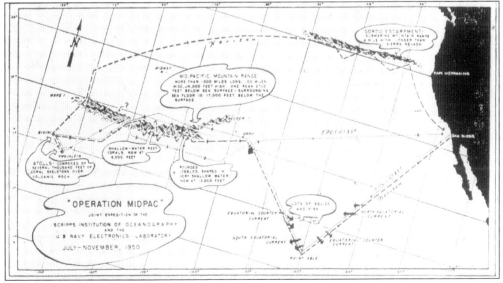

Beginning with Midpac in 1950, Scripps Oceanography undertook a string of major expeditions to explore the Pacific Ocean. Midpac also began a distinctive Scripps tradition of giving those expeditions nicknames. On the cruise, researchers discovered the undersea Mid-Pacific mountain range and confirmed a theory of Charles Darwin about the origin of atolls.

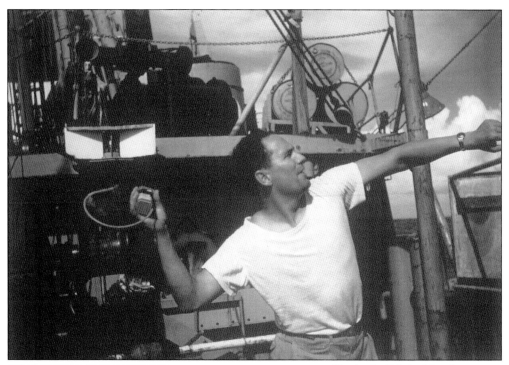

Geologist Edwin Hamilton tosses TNT from the deck of R/V *Horizon* during the Midpac Expedition. Blasts were used for seismic profiling, generating sound waves that were received by listening devices on other ships. The data is used by scientists to understand the structure of the earth beneath the seafloor.

Scripps scientist Claude Palmer takes the temperature of a seawater sample at Scripps Pier around 1950. Surface temperature and salinity readings began in 1916, followed by ocean bottom temperature readings in 1926. They are still made daily at the pier and at eight other stations in the Shore Stations network based at Scripps Oceanography.

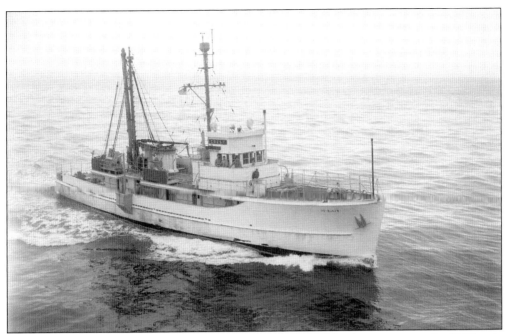

Scripps research vessels *Crest* and *Horizon* conducted some of the first surveys in the California Cooperative Fisheries Investigations (CalCOFI), a program launched to find an answer to the collapse of sardine and anchovy fisheries off the coast in 1946. R/V *Crest* was a former World War II minesweeper provided by the Navy. R/V *Horizon* was a former Navy tug. With a former purse seiner called *Paolina-T* bought with Navy funds, they contributed to CalCOFI surveys and brought the size of the Scripps fleet to four ships. CalCOFI continues to this day, with research vessels traveling to a grid of stations off the California coast every three months to measure conditions ranging from ocean temperature and salinity to quantities of fish eggs and larvae.

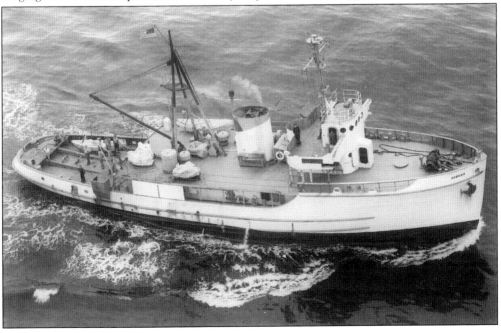

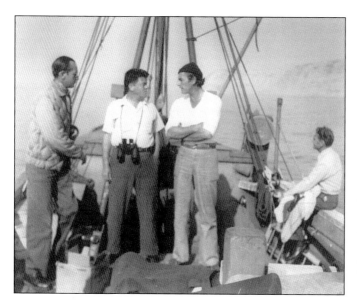

Scripps Oceanography marine biologist Carl Hubbs, with binoculars, chats with actor Errol Flynn during a 1946 expedition to whale breeding grounds in Baja California. The two were joined aboard Errol Flynn's vessel, the *Zaca*, by Flynn's father and Hubbs's friend, the noted marine biologist Theodore Thompson Flynn, standing to the left of Hubbs, and others. The voyage became the subject of a short 1952 documentary narrated by Errol Flynn called "Cruise of the *Zaca*."

Carl and Laura Hubbs were research partners for the entirety of their careers, but the social norms of the times gave Laura Hubbs considerably less credit than her husband, for whom Hubbs Hall on the Scripps campus is named. Like female scientists such as Katherine LaFond, Laura Hubbs worked almost invisibly at Scripps because of university policies against nepotism.

Carl Hubbs looks over kelp on the beach south of Scripps with postdoctoral researcher Eugenie Clark (left) and his student Betty Kampa Boden, who received her doctorate in 1950. Boden went on to a career at Scripps, investigating bioluminescence and other phenomena associated with marine microorganisms. Clark went on to become a renowned shark expert and the author of several books.

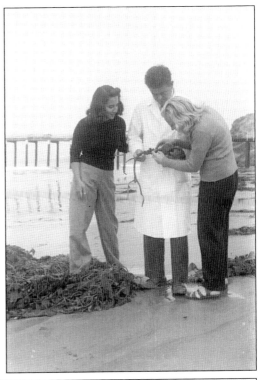

Oceanographer John Isaacs, at far right, helped create many of the instruments used today by seagoing scientists. Among his inventions was the Isaacs-Kidd Midwater Trawl, a device that enabled scientists to collect marine specimens at predesignated depths within the vast expanse of ocean between surface and seafloor. Isaacs Hall on the Scripps campus is named for him.

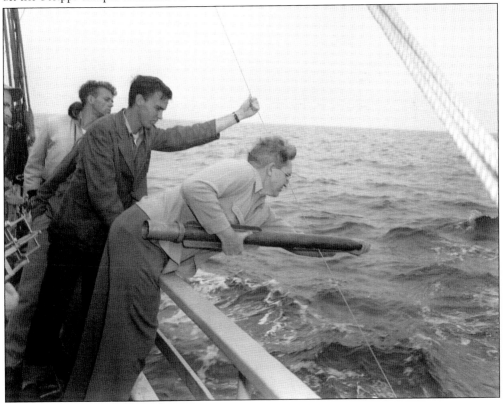

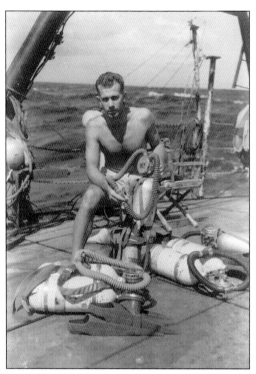

The Capricorn Expedition (1952–1953) employed research vessels *Horizon* and *Spencer F. Baird* in a survey of deep ocean trenches in the western Pacific Ocean. Closer to the surface, the cruise achieved an important first, as Scripps Oceanography researchers, including Willard Bascom, seen left, used scuba gear in research for the first time, collecting rock samples and marine specimens from submerged atolls. Below, Scripps scientists Bascom and Robert Livingston are being towed on a line beneath one of the ships.

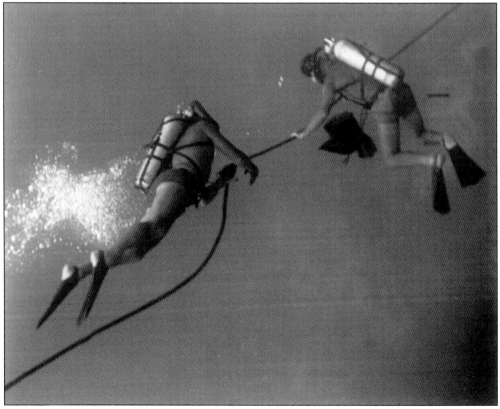

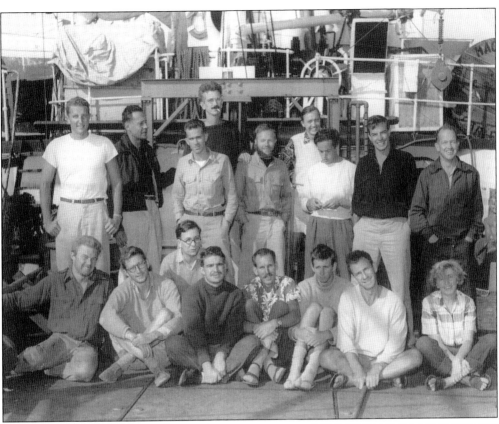

Homeward-bound scientists gather on the fantail of R/V *Spencer F. Baird* from the Capricorn Expedition. A notable addition to the team was Helen Raitt (first row, far right), believed to be the first woman to take part in an extended American oceanographic voyage, despite the fact that Scripps barred women from taking part in overnight research cruises until the 1960s. She would later write a book about the experience: *Exploring the Deep Pacific*.

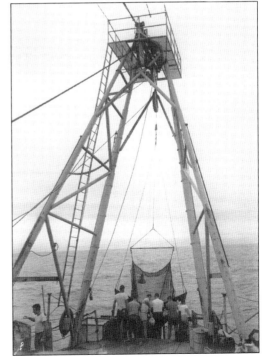

Researchers retrieve an Isaacs-Kidd Midwater Trawl from the depths during the 1953 Transpac Expedition, which surveyed marine life and surface ocean waters on a transect that took scientists aboard research vessel *Spencer F. Baird* to the Bering Sea, Japan, and Hawaii before returning to San Diego. During the port stop in Japan, Scripps scientists presented Emperor Hirohito with a rare mollusk retrieved just off the Japanese coast.

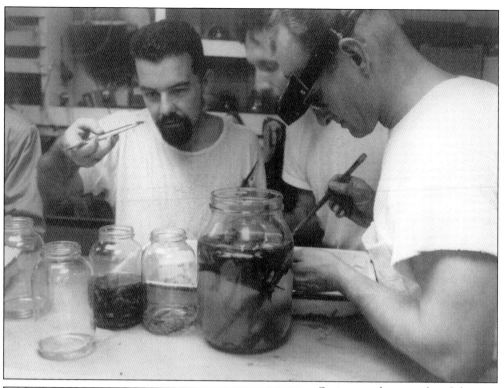

Scripps graduate student John McGowan (left) and Scripps marine biologist Robert Wisner (foreground) sort through fish specimens collected by the Isaacs-Kidd Midwater Trawl during the 1953 Transpac Expedition. Wisner developed a specialty in the study of lanternfish, deep-ocean fishes that use bioluminescence as a communication tool.

Scripps geologist Robert Fisher plots a track during the Vermilion Sea Expedition in 1959. Later that year, Fisher identified the Challenger Deep in the Mariana Trench as the deepest point in the ocean, using soundings made aboard Scripps's R/V *Stranger* to record a depth of 35,600 feet. A year later, the Navy chose that location for the dive of the bathyscaphe *Trieste*, aboard which people traveled to the deepest part of the ocean for the first time in history.

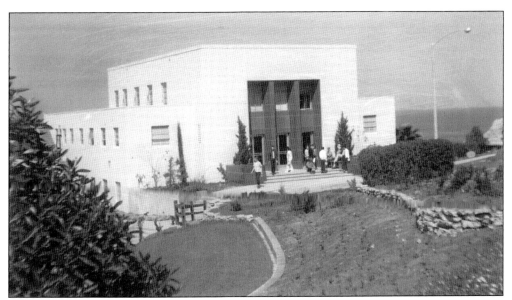

On March 26, 1951, University of California officials dedicated T. Wayland Vaughan Aquarium-Museum, seen here in this 1957 photograph. Original Scripps Oceanography curator Percy Barnhart had envisioned such a building to replace the tiny aquarium over which he presided, but he retired in 1946 before he could realize his dream. In a 1958 report, then-curator Sam Hinton noted that the aquarium was drawing 200,000 visitors annually.

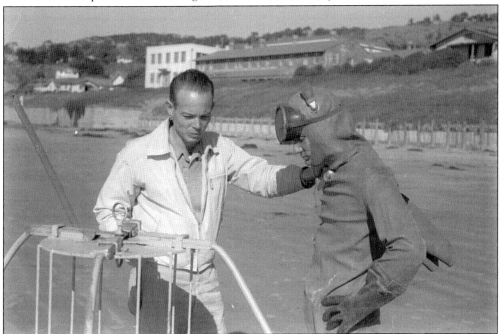

Doug Inman, seen here on Scripps beach with scientist Robert Wisner in dive suit, created the new subfield of coastal oceanography. He made fundamental observations that explain how beaches acquire sand, how sand is transported, and how it disappears from coastlines. To this day, coastal oceanographers around the world refer to themselves as Inman's "grandchildren" or "great-grandchildren," as all can trace their research lineage back to him.

The humble building to the left in this photograph was known as Surfside, the "social facility" of Scripps Oceanography, at which graduate students have hosted a party known as TG every Friday since 1968. The building was torn down in 2007 to make way for a new conference complex. It was replaced by a new version of Surfside in the new complex.

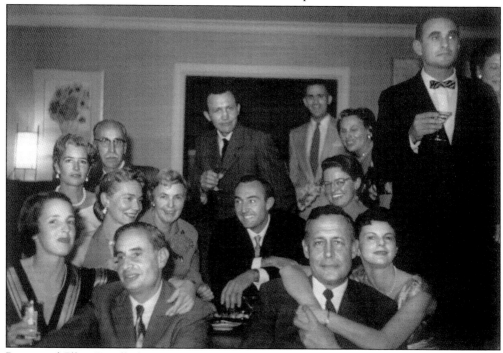

Roger and Ellen Revelle host Scripps colleagues at their home in 1957. From left to right are (first row) Jenny Arrhenius, Walter Elsasser, Roger Revelle, and Shirley Lieberman; (second row) Rhoda Bascom, Helen Raitt, William Van Dorn, an unidentified woman, and Leonard Lieberman (standing); (third row) Ellen Revelle, Carl Eckart, Gustaf Arrhenius, Willard Bascom, and two unidentified people.

Scripps engineer Arthur Raff observes readings of a flux-gate magnetometer in 1960. Using instruments such as this that picked up magnetic anomalies on the seafloor, Scripps scientists helped create a picture of how Earth's tectonic plates were shifting. In the case of the Pacific Ocean, scientists used this information to find that its seafloor is spreading while plates are colliding at continental margins.

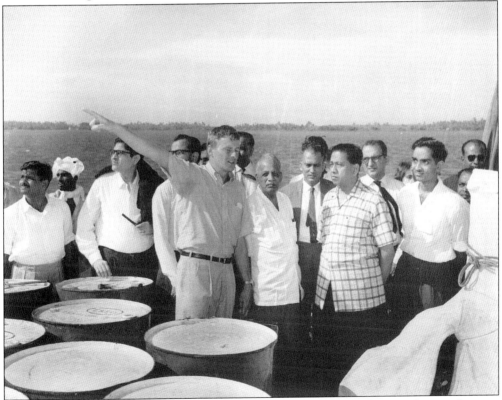

In 1962, Lusiad set a record for the longest Scripps Oceanography expedition to date, sending two Scripps vessels to the Indian Ocean. One of them, R/V *Argo*, traveled 83,000 miles during the yearlong cruise. Its companion, *Horizon*, became the first Scripps vessel to circumnavigate the globe. Here, Scripps scientists lead a press tour aboard R/V *Argo* in Cochin, India, on September 28, 1962.

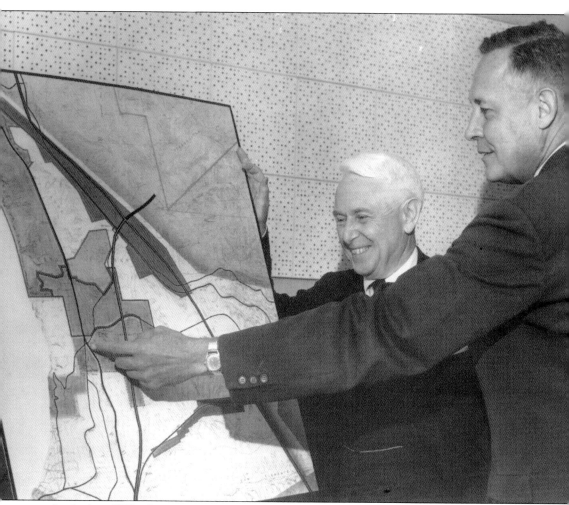

In the late 1950s, Scripps Institution of Oceanography was still affiliated with UCLA, but the arrangement with the university 120 miles away was burdensome for Scripps's doctoral students. As Scripps Oceanography director, Roger Revelle (at right) led the push for the creation of a new University of California campus originally to be named UC La Jolla. The strident campaign, which looked to sway San Diego residents as well as university regents and state legislators, faced fierce resistance from certain quarters, especially from regent Edwin Pauley. Revelle prevailed, and UC San Diego was established in 1960 on a mesa northeast of the Scripps campus.

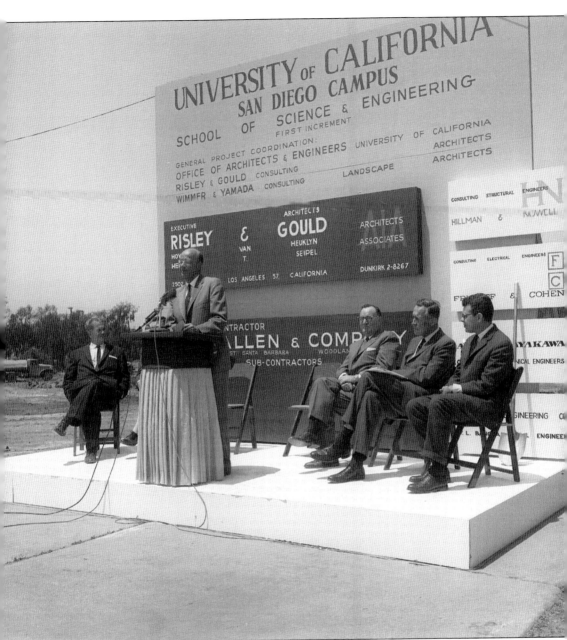

University of California president Clark Kerr speaks at a 1961 ground breaking, flanked by, from left to right, San Diego mayor Charles Dail, California governor Edmund G. Brown, Revelle, and state senator Hugo Fisher. Scripps scientists went about the task of recruiting faculty members from disciplines ranging from humanities to engineering. Revelle's first coup was in luring Nobel Prize–winning chemist Harold Urey, who joined in the recruitment drive. To Revelle's surprise and disappointment, however, the regents selected another scientist, Herbert York, to serve as UC San Diego's first chancellor instead of him. The snub is widely regarded to have been orchestrated by Pauley.

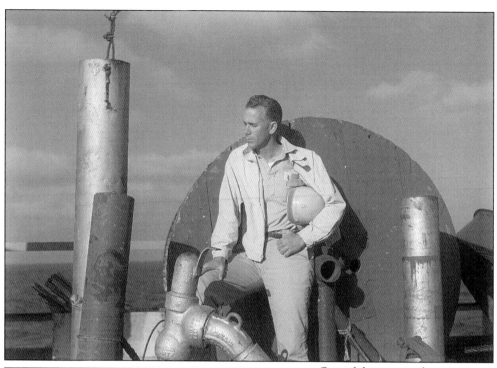

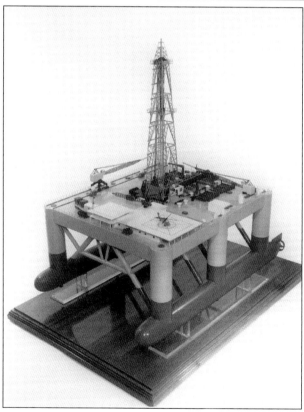

One of the most ambitious Scripps-led expeditions of the 1960s was Project Mohole, an attempt to drill a hole through the seafloor to reach Earth's mantle. Researchers led by Scripps's Willard Bascom (above), including Roger Revelle, Walter Munk, and Gustaf Arrhenius, assembled aboard the modified oil rig CUSS I (an illustration of which is seen at left) at a location off the Mexican coast to conduct a test run. Also on board was the writer John Steinbeck, an acquaintance of several Scripps Oceanography scientists, including Bascom, at whose La Jolla home he stayed before CUSS I departed. Steinbeck would write an article about the experience for *Life* magazine. "The most important and unique equipment we have is the group of men aboard, an elite and motley crew," he wrote in his account. (Above, courtesy of the Willard Bascom family.)

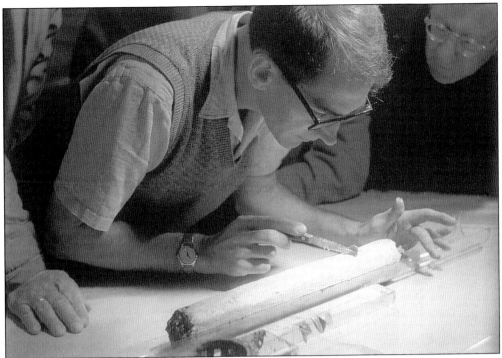

Geologist William Riedel examines a sediment core dredged during Project Mohole. The experiment did not end up with a probe reaching the mantle, but from it came vital innovations in technology, such as dynamic positioning, which enables ships to overcome drift and remain at a fixed point in the ocean. It also led to the creation of the Deep Sea Drilling Project, which morphed into the International Ocean Discovery Program, a collaboration among research centers representing 23 countries that conducts sub-seafloor explorations through deep-sea drilling.

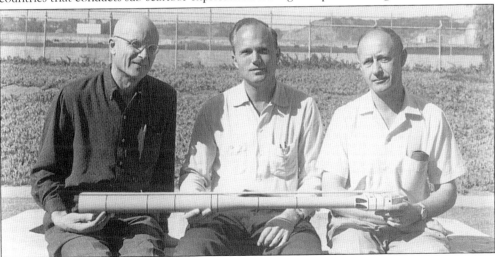

In 1962, from left to right, Scripps scientists Philip Rudnick, Fred Fisher, and Fred Spiess pose with a model of what would become one the world's most unusual marine research instruments. The three designed FLIP (for Floating Instrument Platform), a craft outfitted with large tanks that could be filled with water and cause the platform to "flip" into a vertical position. In that orientation, FLIP scarcely bobs at the ocean surface even during strong storms.

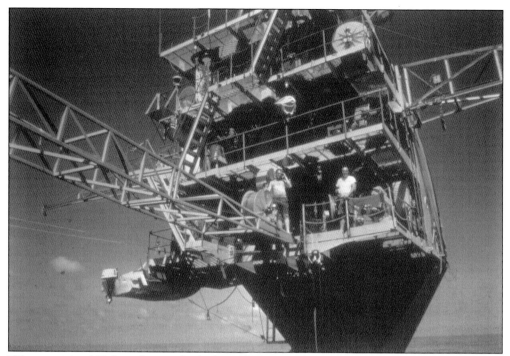

When upright, 300 feet of research platform FLIP are underwater and 55 feet above. The steady nature of FLIP enables scientists to make precise measurements of ocean circulation and other physical processes. On certain occasions, the platform has endured swells of 65 feet that washed over its entire above-surface portion.

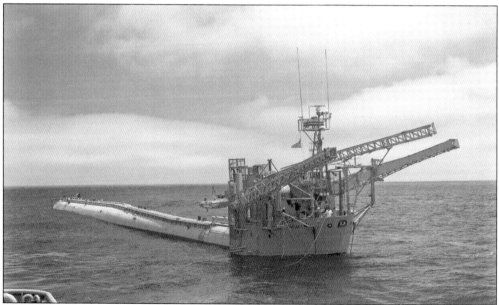

R/P FLIP has no power of its own, hence it is classified as a platform rather than a vessel. Typically a vessel in the fleet of the US Navy, which owns FLIP, tows it to desired locations. Many of FLIP's missions have been in service of studies of sound propagation in the ocean owing to the quiet the engineless platform provides.

Fred Spiess, a former World War II submariner, took over as acting director of Scripps in 1961 before assuming full directorship in 1964 as Revelle's duties, particularly that of science advisor to US secretary of the interior Stewart Udall, took him off campus for an increasing amount of time.

Physicist Hugh Bradner is seen in a drysuit in 1953. In the early 1950s, Bradner began experimenting with neoprene as a material for dive suits. The wetsuit he invented would revolutionize scuba diving. Bradner joined Scripps in 1961, having perfected the wetsuit's design earlier with the help of Scripps Oceanography divers, who tried out early models during scuba classes they led at the La Jolla Beach and Tennis Club.

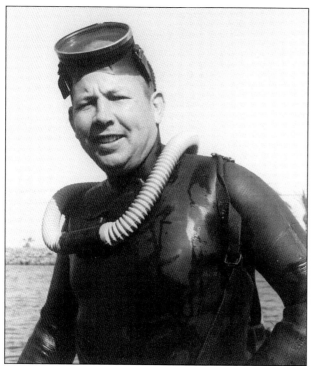

Scripps Oceanography purchased its first Aqua-Lung scuba in 1950, and graduate student Conrad Limbaugh was one of its most ardent users. As Scripps's first dive officer, he was among a group of Scripps researchers who created diving rules and regulations for the University of California system in 1954. Tragically, Limbaugh drowned in March 1960 during a dive in an underwater cavern in France.

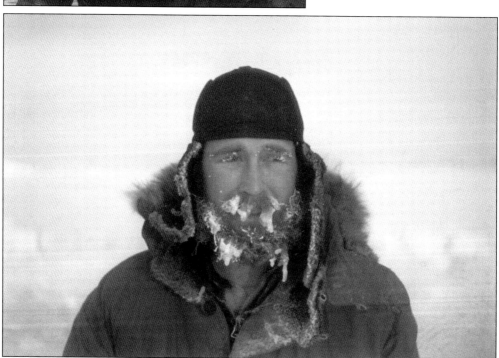

Pioneering Scripps Oceanography marine biologist Paul Dayton deals with the cold near McMurdo Station, Antarctica, in 1964. Dayton was part of an early wave of scientists who incorporated dives into their polar research, devising best practices as they went. Dayton documented more than 50 years' worth of ecological change on the Antarctic seafloor caused by shifts in sea ice movements.

During a late-1980s dive, research physiologist Gerald Kooyman films emperor penguins as they dive in order to understand the behaviors that enable them to remain underwater for extended periods as they hunt for fish. Kooyman first dove in Antarctica in the early 1960s and developed instruments called time-depth recorders that he attached to penguins and marine mammals. Penguins, he found, could dive to a depth of more than 1,600 feet in search of food.

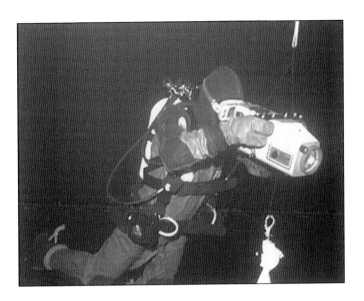

Jacques Cousteau (left), diving researcher André Laban (center), and Scripps Oceanography student Robert Floyd Dill (right) are pictured aboard Cousteau's ship *Calypso* around 1959. Cousteau's association with Scripps lasted for several decades. In 1964, Scripps scientists piloted Cousteau's "diving saucer" to view the Scripps submarine canyon.

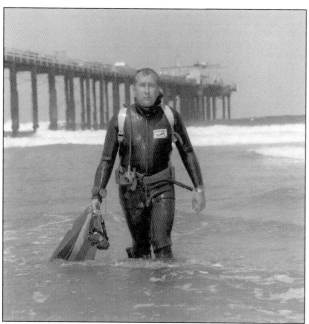

James Stewart, Scripps Oceanography's second dive officer, was a member of the Bottom Scratchers, the world's oldest freediving club, as a young San Diego resident. During the early 1960s, Stewart developed the original *University Guide for Diving Safety*, and in 1967, he began supervising the training of scientists in polar research diving.

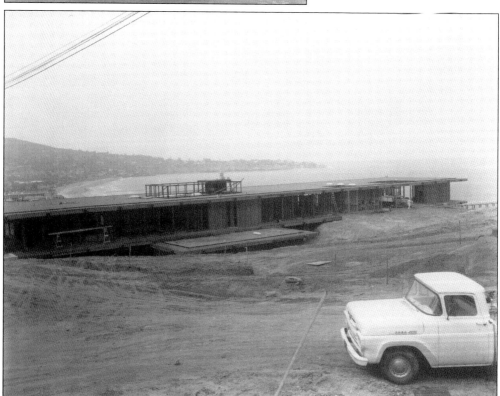

The Institute of Geophysics and Planetary Physics (IGPP), shown under construction here, began as a Scripps-based expansion of the University of California's systemwide Institute of Geophysics in 1960. In part to stop geophysicist Walter Munk from accepting a position at Harvard, Scripps director Roger Revelle invited him to create this new center instead.

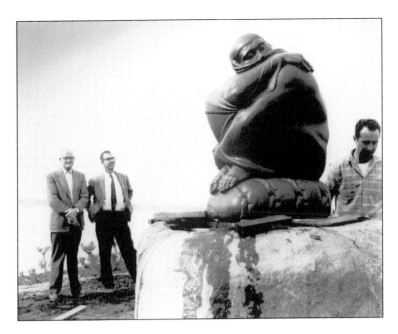

Philanthropist Cecil H. Green (left) and Munk take in *Spring Stirring*, a sculpture by San Diego artist Donal Hord on display on the patio of the Munk Laboratory of the IGPP complex. Cecil Green, the founder of Texas Instruments, and his wife, Ida, funded the sculpture and were constant supporters of the institute throughout their lifetimes.

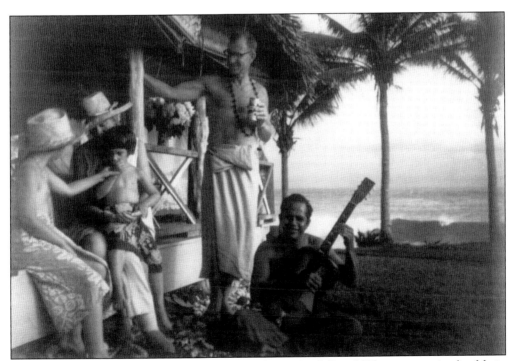

Walter Munk (standing), wife Judith, and daughters Kendall and Edie are seen in the *fale* in which they lived while on American Samoa in 1963 while Walter led a project to understand the evolution of waves across entire ocean basins. The project was captured in the documentary *Waves across the Pacific*.

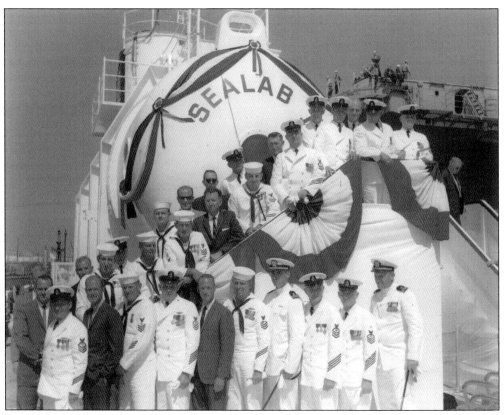

Beginning August 28, 1965, SEALAB II, a manned underwater saturation habitat, was operated for 45 days roughly a mile off the Scripps Pier at a depth of 205 feet. Astronaut Scott Carpenter set a record for days spent under the sea, staying aboard for two of the three shifts, or 30 days. SEALAB II aquanauts included several Scripps Oceanography staff and students.

Among SEALAB II participants representing Scripps Oceanography were Art Flechsig (left) and Rick Grigg. Grigg was an oceanographer but more famous as a champion longboard rider. Just over a year after SEALAB II, he won the Duke Kahanamoku Invitational in Hawaii. Eventually, he became a scientist at the University of Hawaii.

Edward "Jerry" Winterer of Scripps (right) shows off a successful dredge hauled from the seafloor off the Southern California coast. Winterer, a marine geologist, was among the first scientists to investigate sediments in the deep ocean through the Deep Sea Drilling Program. The program has helped scientists reconstruct 150 million years of seafloor history.

Coastal oceanographer Douglas Inman led the design of the Hydraulics Laboratory. The "Hydro Lab," as it is widely known, was constructed in 1964. With its distinctive wave-shaped roofline and all-wooden construction, it was in its earliest years a home to Scripps social events, hosting dances in the same confines that housed advanced fluid mechanics instruments.

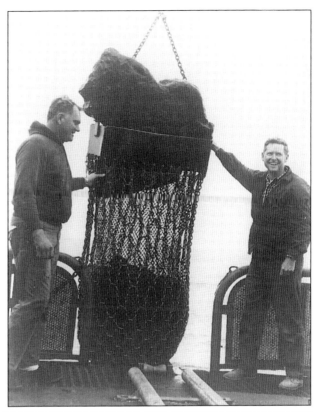

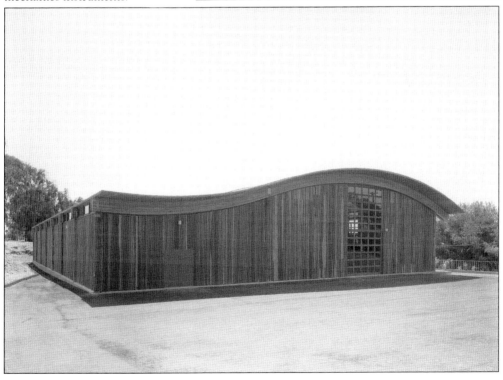

Scripps oceanographer Joe Reid won the Albatross Award in 1988 from the American Miscellaneous Society. The society is a tongue-in-cheek organization of scientists that presents "Albie," the stuffed albatross, to researchers for unusual ideas. Reid won in 1988 for his "outrageous insistence that ocean circulation models bear some resemblance to reality." Reid was, in fact, one of the world's most influential ocean circulation experts, with the maps he created still authoritative decades after he created them.

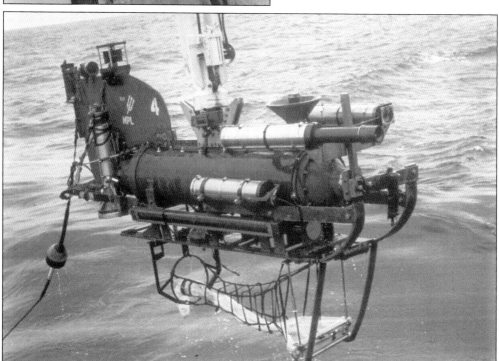

Scripps Oceanography began the development of the instrument DeepTow in 1961. The submersible device was the forerunner of remotely operated unmanned oceanographic systems in use today. The device could be outfitted with sonar to create detailed images of the seafloor as well as sediments and rocks beneath it.

Ed Goldberg was a marine chemist at Scripps Institution of Oceanography. Among his most noted work was his identification of tributyltin as a toxic chemical in marine paint fouling California harbors and his role in the creation of the 1975 EPA-sponsored Mussel Watch program to observe US coastal marine pollution.

Ichthyologist Richard Rosenblatt oversaw the growth of Scripps Oceanography's collections of marine vertebrates as curator when he joined Scripps in 1958. Throughout expeditions of the era, researchers, regardless of their academic discipline, would collect marine specimens to bring back to Scripps Oceanography, "kind of like tithing," Rosenblatt would later say.

In 1963, UC San Diego chancellor Herbert York announced he would be stepping down, opening up for a second time an opportunity for Roger Revelle to take the position. Despite the support of University of California president Clark Kerr, the factions that had been aligned against Revelle when UC San Diego was established were still present and too powerful to overcome. Reluctantly, he accepted a position at Harvard University. On September 26, 1964, the Scripps community sent the Revelles off with a party in the brand-new Hydraulics Laboratory on campus. The event featured one-of-a-kind dances, including the flip-flop dance performed here by Nan Limbaugh (left) and Thea Schultze.

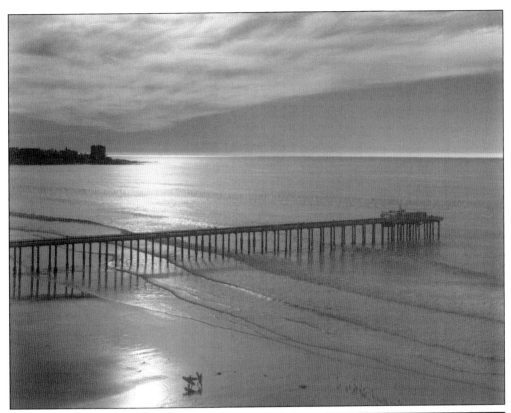

In 1963, the University of California commissioned photographer Ansel Adams and author Nancy Newhall to create a book commemorating the university's centennial. Over the next several years, Adams traveled to UC campuses to capture their most iconic imagery. In December 1966, he captured several scenes at UC San Diego, including the Scripps Pier (above), the architecture of the campus, and researchers at work. Seen to the right, Adams photographed Scripps geophysicist Walter Munk with a deep-ocean tidal recorder inside a lab at IGPP. (Both courtesy of Sweeney/Rubin Ansel Adams Fiat Lux Collection, California Museum of Photography, University of California, Riverside.)

Physicist William Nierenberg, a veteran of the Manhattan Project, became director of Scripps Oceanography in July 1965. Nierenberg oversaw the rise of the Deep Sea Drilling Project and championed advancements such as installing computers onboard research vessels. During his tenure, climate change research at Scripps expanded dramatically, though Nierenberg himself did not view climate change as a problem likely to adversely affect society.

Geochemist Miriam Kastner, at right, seen here with marine geologist Rachel Haymon, became the second female professor at Scripps Oceanography when she joined in 1972 and, later, the first tenured female professor. Kastner has pioneered areas of seawater chemistry research, in particular on methane hydrates, structures in which the gas methane is essentially trapped in solid form under intense cold and pressure on the seafloor.

Oceanographer Peter Lonsdale made a historic discovery in 1976 that marine organisms were living at hydrothermal vents on the seafloor. The vents, superheated by geothermal energy, exist at locations in the ocean associated with tectonic activities. With colleagues, Lonsdale captured for the first time images of mollusks and other life forms adapted to the harsh vent environment.

Following Lonsdale's discovery, marine biologist Robert Hessler was one of the first scientists to identify lifeforms at hydrothermal vents in the ocean in 1979. Earlier in his career, Hessler had discovered the deep oceans to be a place of complex biodiversity, upending notions that the deep oceans were largely incapable of supporting rich marine life.

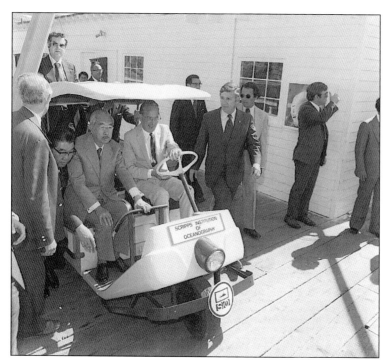

William Nierenberg drives Japan's Emperor Hirohito around campus during the emperor's 1975 visit to Scripps during a US tour. Hessler and biologist William Newman gave the emperor a presentation of the institution's biological specimens. Hirohito himself was a noted amateur marine biologist.

Gerald Kooyman (second from left), who studies the physiology of animals such as seals, sea lions, and penguins during dives for food, described his research to Queen Elizabeth II and Prince Philip during their 1983 visit to campus. To the right of Prince Philip is Scripps director William Nierenberg.

Five

UNCOVERING CLIMATE CHANGE

Carbon dioxide (CO_2) gas is emitted by myriad societal activities, from the driving of cars to the manufacture of cement to the generation of electricity. The science that identified the heat-trapping ability of the gas had been established at the beginning of the 20th century, when there were still few autos on the roads. Swedish chemist Svante Arrhenius, the grandfather of Scripps Oceanography researcher Gustaf Arrhenius, had described the greenhouse effect of CO_2 in 1896 and proposed that emissions would result in warming. By the late 1930s, English engineer Guy Callendar had linked rising global temperatures to rising levels of carbon dioxide in the atmosphere.

In the mid-1950s, the concept was at the forefront of Scripps director Roger Revelle's thinking. Many scientists were not alarmed by Callendar's conclusions because they thought the oceans would absorb most excess carbon dioxide. Revelle, however, reported that the oceans were only taking up a small portion of it in a prophetic 1957 research paper. He and coauthor Hans Suess concluded that human activities were putting into the atmosphere in a matter of decades carbon that had taken hundreds of millions of years to be sequestered in sedimentary rocks.

The paper roughly coincided with Revelle's recruitment of a young geochemist named Charles David Keeling. Shortly after arriving at Scripps in 1956, Dave Keeling established CO_2 monitoring stations at the South Pole and atop Hawaii's Mauna Loa. The measurements at Mauna Loa, which Keeling fought for and maintained for nearly five decades, would become the most famous—the icon of modern climate change. The first daily reading of CO_2 in air recorded there on March 30, 1958, was 316.16 parts per million (ppm).

Keeling's work would be complemented by a range of inquiries by Scripps Oceanography colleagues into the nature of climate, such as Pacific Ocean influences on North American weather patterns, seasonal climate forecasting, and the reconstruction of ancient climate preserved in polar ice. The effort was aided by improved computing power, which could yield ever-more-accurate simulations of past, present, and future scenarios known as climate models. Robotic instruments developed largely at Scripps would provide the most transformative leap in oceanography in the field's century of existence: the ability to constantly monitor almost all the oceans in real time. This new ability has enabled science to understand the deep memory of climate and put present-day events in perspective.

Dave Keeling is seen in his laboratory in 1959. He had already discovered that levels of CO_2 in the atmosphere were consistent throughout the world, having developed an instrument known as a manometer for making precise measurements of the gas that he deployed in several locations. (Courtesy of Joseph G. Strauch.)

NOAA's Mauna Loa Observatory is the location at which Keeling Curve CO_2 measurements are made. Keeling selected the barren volcanic mountaintop as an ideal place to make carbon dioxide measurements. Hawaii's location in the middle of the Pacific Ocean afforded it a location that best represented the average of CO_2 concentrations in the Northern Hemisphere, where exists the majority of the world's vegetation. (Courtesy of Susan Cobb/NOAA.)

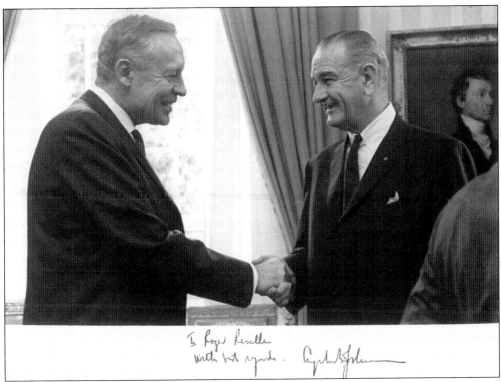

Roger Revelle meets with Pres. Lyndon Johnson on February 6, 1967. Revelle was a member of Johnson's Science Advisory Panel. With Keeling, Scripps Oceanography geochemist Harmon Craig and others, Revelle evaluated rising carbon dioxide levels in the 1965 document "Restoring the Quality of Our Environment," which mentioned a rise in sea level of 400 feet as a potential consequence of fossil fuel use. (Courtesy of the White House.)

Jerome Namias, a National Weather Service veteran specializing in extended weather forecasts, joined Scripps full-time in 1972 as its first true climate scientist. The first director of the Climate Research Group at Scripps, later named the Climate Research Division, he pioneered seasonal forecasting that linked ocean trends to continental weather patterns.

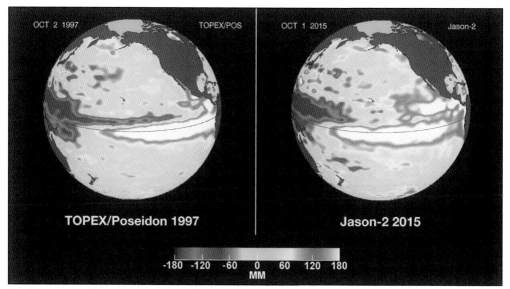

Satellite images show elevated sea surface in the eastern Pacific Ocean during major El Niño events in 1997 and 2015. By the 1990s, the climate science community had realized the importance of developing the ability to predict the phenomenon after faulty observations caused researchers to dismiss early signs of a similar major El Niño in 1982. El Niño became a major focus of climate research at Scripps following that destructive event. (Courtesy of NASA/JPL-Caltech.)

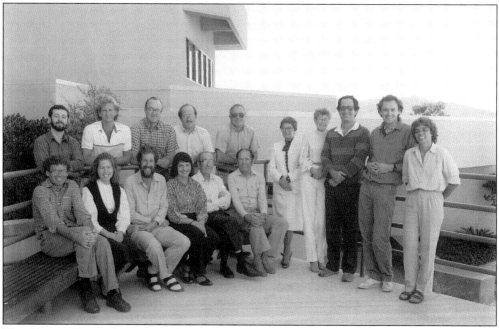

The Climate Research Group gathers for a photograph in October 1985. Richard Somerville, seated in the first row, third from left, took over as head of the group from Namias in 1979 when he became Scripps's first professor of atmospheric sciences. The group included members of the Experimental Climate Prediction Center, headed by John Roads (standing, third from right), which developed methods for forecasting El Niño and other phenomena such as droughts and fire weather.

Climate researcher Dan Cayan (right), with colleague Larry Riddle, found evidence in the 1990s that warming temperatures were leading to an earlier onset of spring over the western United States. Cayan's subsequent work has led to more detailed projections of climate change and impacts over California and western North America.

Edward Frieman became director of Scripps Oceanography in 1986 after a career spent largely in federal science administration. Frieman created a new division devoted to atmospheric science and expanded Scripps research in satellite oceanography and space science. His goal was to position Scripps as an authority on climate change, which was rapidly becoming a leading science topic and a controversial social issue in the late 1980s.

Frieman succeeded in recruiting renowned climate and atmospheric scientist Veerabhadran Ramanathan in 1990. Seen at right with colleague and Nobel laureate Paul Crutzen, Ramanathan embarked on the Indian Ocean Experiment (INDOEX), in which he identified the climate change effect of agents besides carbon dioxide in South Asia. That was followed by Project Atmospheric Brown Clouds, which revealed the climate effects of South Asia's pervasive air pollution.

Scripps development engineer Mike Goldin works at an ice camp set up on the Beaufort Sea during the 1997–1998 Surface Heat Budget of the Arctic Ocean (SHEBA) experiment. With warming climate, ice camps now typically require the presence of a backup ship. The Scripps Oceanography effort in SHEBA, led by veteran Scripps oceanographer Rob Pinkel, was disrupted several times when the ice beneath the camp cracked and opened.

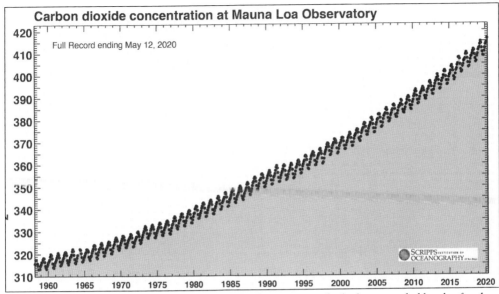

The Keeling Curve, providing daily updates at keelingcurve.ucsd.edu, has recorded levels of carbon dioxide in the atmosphere approaching 420 parts per million of air in 2020. Levels of CO_2 had scarcely exceeded 300 ppm in the previous 800,000 years. Scientists believe it is possible that levels could reach 750 ppm by 2100.

In 2002, Pres. George W. Bush selected Dave Keeling to receive the National Medal of Science, the nation's highest award for lifetime achievement in scientific research. The history of the Keeling Curve involved Keeling's own fight to keep the measurement going. (Courtesy of the White House.)

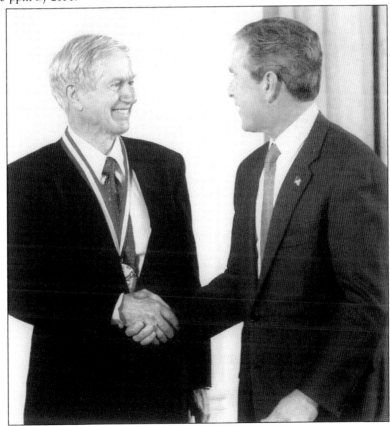

Ralph Keeling took over the Scripps CO_2 program after his father Dave's death in 2005. The group continues to track trends in the annual cycle of carbon dioxide in the atmosphere while tracking its inexorable rise. Keeling also oversees a complementary measurement of atmospheric oxygen, which has declined over the same time period since CO_2 began its sharp increase.

Climate scientist Tim Barnett, seen here at a February 2008 press conference, and colleague David Pierce illustrated the problems posed by climate change when they concluded that Lake Mead on the Colorado River, the source of drinking water for millions of people, stood a 50/50 chance of falling below usable water distribution limits by the 2020s if climate and usage conditions did not change. By 2020, their prediction had largely been borne out.

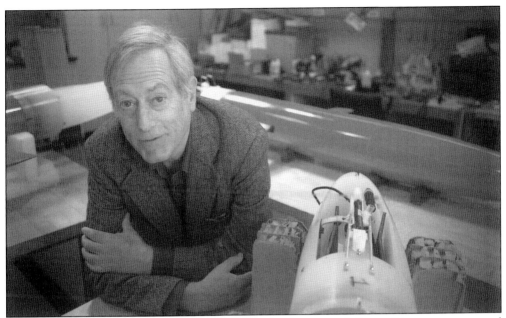
Oceanographer Russ Davis poses with Spray gliders that he invented. Spray gliders are programmed to dive and resurface along predetermined transects to measure ocean conditions. Davis's devices, including floats in a network called Argo, revolutionized science's ability to observe ocean phenomena.

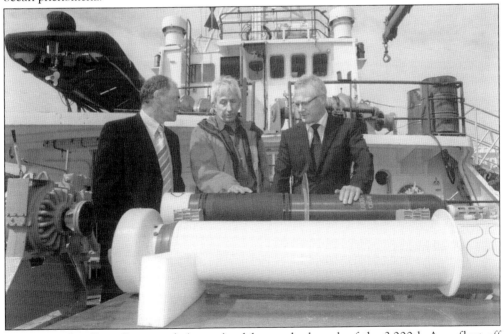
Oceanographer Dean Roemmich (center) celebrates the launch of the 3,000th Argo float off New Zealand in 2007. The occasion signified comprehensive coverage of all ocean basins by the network. Argo floats measure oceans' "vital signs" such as temperature, salinity, and current speed and direction. As the program goes on, it will document ocean cycles that play out over the course of decades.

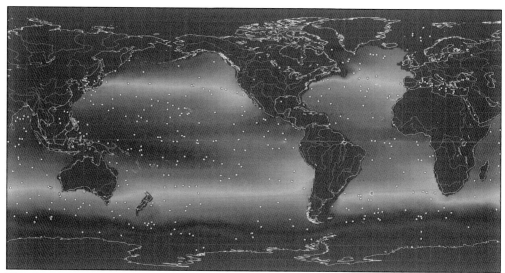

The Argo program observes more than half of the total space occupied by all world oceans, with a more detailed picture being developed all the time as the network expands. In addition to nearly 4,000 floats that record data to depths of 2,000 meters (6,500 feet), a second generation of floats known collectively as Deep Argo has expanded the network's reach to 6,000 meters (20,000 feet).

Glaciologist Helen Amanda Fricker is seen as a graduate student at a landing site on Amery Ice Shelf in East Antarctica in 1995. Fricker has led studies of the loss of Antarctic ice mass and its relationship to climate change using satellite and field observations. Fricker also discovered that the continent contains active subglacial lakes and has studied how physical changes in Antarctica contribute to global sea-level rise. (Courtesy of Helen Amanda Fricker.)

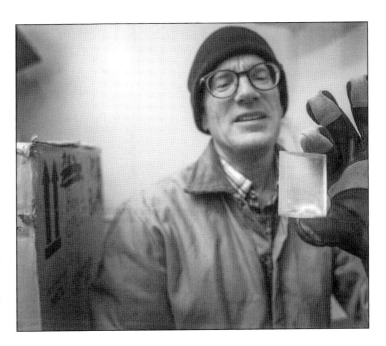

Geoscientist Jeff Severinghaus holds up a slice of ancient cored ice. The bubbles within samples of ice taken from places like Antarctica and Greenland allow scientists to observe the composition of the air when they were formed millions of years ago. Severinghaus is part of international efforts to probe ever-older points in history to understand natural climate cycles and how the present day compares to ancient climate events.

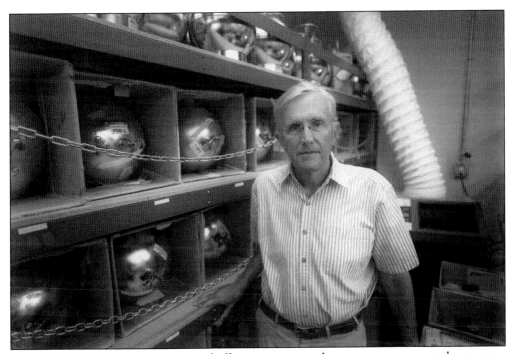

Scripps scientists lead an international effort to continuously measure potent greenhouse gases in the global atmosphere. Geochemist Ray Weiss is seen here with an archive of air samples collected at Scripps Pier for measurement of historical trends. Weiss is coleader of the Advanced Global Atmospheric Gases Experiment (AGAGE) program. Data from stations around the world are used to provide an independent check of emissions reported by governments and industries.

In 1994, the United Nations began convening an annual negotiation of climate change policy among countries that were party to the UN Framework Convention on Climate Change. The University of California has sent delegates to the negotiations known as Conferences of the Parties, or COPs, since 2000 to advise policymakers on climate science developments. Above, Scripps student Osinachi Ajoku (second from left) speaks during a presentation at 2018's COP24 in Katowice, Poland, flanked by Scripps student Tashiana Osborne (center) and Scripps postdoctoral researcher Yassir Eddebbar (far right). Below, Southern California congressmen Scott Peters, at center with hand on instrument, and Mike Levin, at center left, are flanked by UC delegation members from Scripps at COP25 in Madrid, Spain.

Six

A New Mission

The second century of Scripps Institution of Oceanography came accompanied by a new mission. The human causes of climate change had been identified, and at the beginning of the 21st century, Scripps Oceanography set as one of its main research goals the understanding and protection of the planet. Scientists understood that the problems facing the planet went beyond climate change. Plastic pollution, development in environmentally sensitive areas, overfishing, the introduction of toxins into marine food webs, and destructive farming practices have placed stresses on the planet unprecedented in terms of their rapid appearance. The institution's emphasis on collaborative research among varied disciplines and commitment to long-term comprehensive observation remain core attributes.

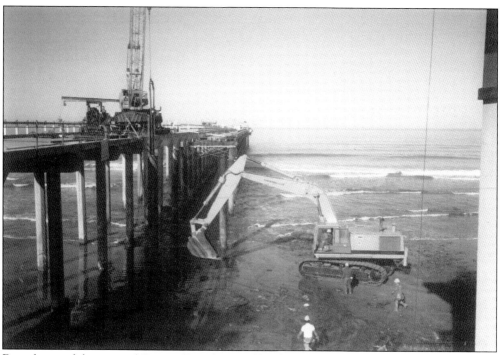

Demolition of the original Scripps Pier, damaged by the ravages of time, takes place along with the construction of the new Ellen Browning Scripps Memorial Pier in 1988. The new pier is 1,084 feet long and hosts numerous research stations as well as a boat launch platform.

Ellen Virginia (Clark) Revelle, wife of former Scripps director Roger Revelle, christens the Ellen Browning Scripps Memorial Pier with a bottle of champagne on July 15, 1989. She and the pier were named after her great-aunt Ellen Browning Scripps, one of the founders of Scripps Institution of Oceanography.

Roger Revelle is seen at right in his later years. Below, his namesake Scripps Oceanography research vessel *Roger Revelle* is launched at a Moss Point, Mississippi, shipyard on April 20, 1995. By the late 1970s, Revelle had begun to spend more time back in San Diego. He again became a major figure in the city as a philanthropist and thought leader. He reaped awards acknowledging his life accomplishments, ranging from the National Medal of Science in 1990 to "Mr. San Diego," which was awarded by the Rotary Club in 1988. By 1990, San Diego ranked first among America's top-10 cities in the number of residents with college degrees, a feat colleagues attributed largely to him. On July 15, 1991, Revelle died at the age of 82. Six days later, his ashes were scattered from Scripps research vessel *New Horizon* into the Pacific Ocean.

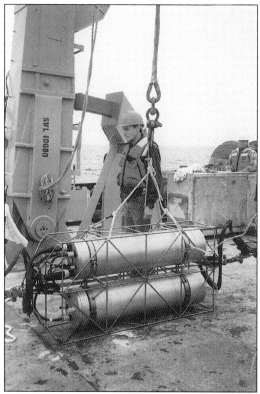

Scripps oceanographer Peter Worcester prepares an acoustic receiver during the Acoustic Thermometry of Ocean Climate (ATOC) project, which started in 1996 to determine whether ocean temperature could be taken by measuring the time it took acoustic signals to travel from a source to a receiver. ATOC scientists successfully measured changes in temperature over a large area of the North Pacific Ocean, providing a tool for documenting the effects of climate change on the oceans.

Charles Kennel, for whom Kennel Way on the Scripps campus is named, followed Edward Frieman as director of Scripps Oceanography in 1998. A specialist in plasma physics, Kennel previously served as associate administrator for NASA, directing Mission to Planet Earth, the world's largest earth science program, from 1994 to 1996.

Oceanographer Lynne Talley joined Scripps in 1984 and has become a world leader in depicting ocean circulation, particularly in subpolar regions, and how the transport of heat and freshwater in the oceans affect climate. The lead author of the textbook *Descriptive Physical Oceanography: An Introduction*, her emphasis in recent years has been on processes in the Southern Ocean.

Scripps oceanographer Jim Swift set the record for northernmost playing of the bassoon. Swift, a member of the La Jolla Symphony, played on the North Pole in September 2005. He served as director of the World Ocean Circulation Experiment Hydrographic Program office at Scripps and has taken part in numerous expeditions in all world oceans to study circulation and other physical properties of the oceans.

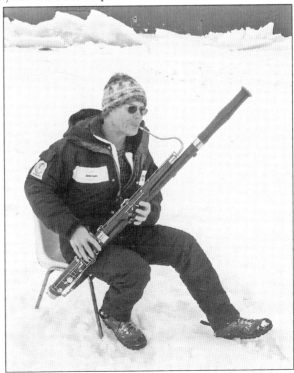

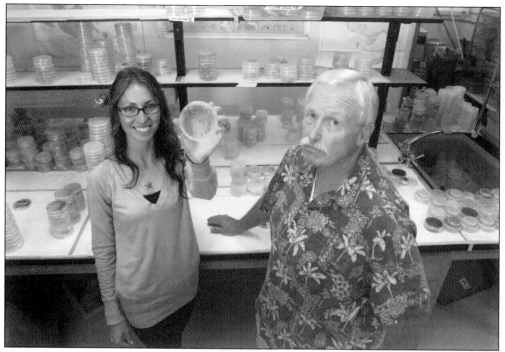

Marine chemist William Fenical, seen here with research associate Lauren Paul, joined Scripps Oceanography in 1973 and founded the Center for Marine Biotechnology and Biomedicine in 1998. The center is a global leader in the search for compounds found in the oceans that could have medicinal value. Fenical has studied the role of compounds used in marine organisms' chemical defense that could lead to novel therapeutics in human diseases.

A compound produced by bacteria in the genus Salinispora was in 2020 being tested on patients with the brain cancer glioblastoma at hospitals across the globe in a study nearing its final test phase. Pictured are strains of the bacteria being cultured in the lab. (Courtesy of Nastassia Patin.)

Since the 1990s, Scripps scientists such as Ed Parnell (pictured) and Paul Dayton have lobbied city and state officials to create effective marine reserves around California. They helped shape the two protected areas bordered at Scripps Pier—the San Diego–Scripps State Marine Conservation Area and the Matlahuayl State Marine Reserve—and have advised officials on reserve design in other areas of California.

Hundreds of students, staff members, and scientists crowded into Surfside for one final TG party on January 5, 2007. The beloved but by-then decrepit building had been the Scripps social nerve center since the 1960s. Two weeks after this send-off, the building was demolished. A new Surfside now exists as part of the Robert Paine Scripps Forum for Science, Society, and the Environment complex.

Scripps Oceanography geophysicist and administrator John Orcutt (right) interviews filmmaker James Cameron on May 31, 2013. Scripps honored Cameron with the 2013 Nierenberg Prize for Science in the Public Interest in recognition of Cameron's 2012 dive to the deepest part of the oceans, the Challenger Deep in the Mariana Trench. The voyage, called DEEPSEA CHALLENGE, drew on expertise from Scripps development engineer Kevin Hardy, and Scripps marine microbiologist Doug Bartlett served as its chief scientist.

Scripps Oceanography Marine Vertebrate Collection manager H.J. Walker codiscovered the world's smallest vertebrate, the stout infantfish, in 2004. The collection contains two million specimens representing 5,600 species. In 2019, research centers around the world like Scripps identified 353 new species of fishes, an indication of how much more there is to discover in the oceans. (Courtesy of Marc Tule.)

Tony Haymet became the 10th director of Scripps Oceanography in 2006. Haymet had to steer Scripps through a period in which the University of California had to deal with an economic downturn and substantial budget cuts. He also, however, spearheaded a number of high-profile events that brought celebrities including Prince Albert II of Monaco, Al Gore, and filmmaker James Cameron to campus.

A diver maneuvers over a downed World War II fighter plane found in shallow waters off Palau. Several Scripps scientists led by oceanographer Eric Terrill have employed cutting-edge technology to locate aircraft and ships lost at sea in war and bring closure to the families of troops termed missing in action. (Courtesy of Eric Terrill.)

Scripps Oceanography researchers made one of the first scientific surveys of a region known as the "Great Pacific Garbage Patch" during 2009's SEAPLEX cruise. In an ocean gyre between Hawaii and California where currents converge, they evaluated the extent of plastic accumulation at the ocean surface, which consists largely of floating trash that breaks down slowly. Overall, the garbage patch is thought to be roughly the size of the state of Texas and contains debris ranging from fishing nets to bits of plastic that fishes and turtles can mistake as food and ingest. Research institutions and private entities have since tested ways to skim the plastic pollution from the patch surface, though no viable method has yet been found. (Both courtesy of James Leichter.)

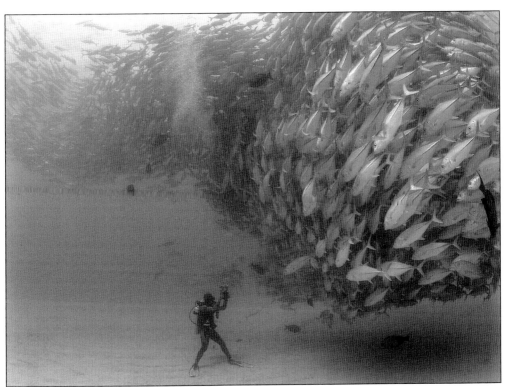

Marine ecologist Octavio Aburto has documented the successes of marine reserves in Mexico through research and photography. Above, he captured a fellow diver photographing a school of jacks off Cabo Pulmo in Baja California. In the 1990s, fishers in the tiny community near Cabo San Lucas opted to create a marine reserve as a means of protecting their livelihood. The reserve is now one of the most successful in the world, as the biodiversity of marine life there has increased dramatically, and the town has become a dive tourism destination. Below, he photographed his research team installing equipment to gather data on mangroves, which not only absorb carbon dioxide but also protect coastlines from storm damage. In 2008, Aburto led a study that calculated the dollar value of leaving mangrove forests undisturbed. (Both courtesy of Octavio Aburto.)

Atmospheric chemist Kimberly Prather, seen here at left with researchers Francesa Malfatti and Christopher Lee at Scripps's Hydraulics Facility, revolutionized the study of how ocean emissions of gases and marine aerosols affect climate through their influence on the formation of clouds. She is the founding director of the National Science Foundation Center for Aerosol Impacts on Chemistry of the Environment (CAICE), which was formed in 2013. CAICE successfully moved the ocean-atmosphere system into a laboratory setting to enable studies into how ocean microbes influence climate and human health. In 2020, Prather emerged as a leading American researcher who spoke up to warn the public that the global COVID-19 pandemic was happening due to the SARS-CoV-2 virus being spread as an aerosol. Her efforts led to the recognition of the importance of airborne transmission and revision of public health guidelines into how to limit the spread of the virus. (Courtesy of NSF-CAICE.)

Researchers from the Scripps Polar Center led by physical oceanographer Fiamma Straneo, along with colleagues from other universities, explored icebergs in southeast Greenland in 2018. As the Greenland Ice Sheet melts, the shedding of increasing numbers of icebergs has implications for sea-level rise and circulation in the North Atlantic Ocean. Here, the crew clears away ice chunks before retrieving a submerged instrument. (Courtesy of Alex Hamel.)

The Scripps Center for Climate Change Impacts and Adaptation focuses on giving society strategies to cope with the inevitable consequences of global warming. Much of the center's work considers changes to the California coastline. Scripps researchers seen here prepare to launch drones to image the elevation of cliffs and beaches. The information enables them to track erosion over time.

A class descends from Scripps Pier in preparation for a training dive. Scripps Diving Operations staff train and certify as many as 36 people every year. In 2019, Scripps had 149 divers logging nearly 4,000 dives, making it one of the largest, most active, and diverse scientific diving programs in the United States.

Research biologist Maria Vernet places bottles filled with phytoplankton into an incubator during 2016's FjordEco Cruise. Vernet oversaw a mission to understand the activity of phytoplankton in Antarctica's Andvord Bay and how forces like melting glaciers affected that activity. The bay is located in one of the most fertile ocean regions on Earth. (Courtesy of Maria Stenzel.)

Scripps Oceanography produced two astronauts who visited space within a decade of each other. Alumna Megan McArthur (right), who received her PhD in 2002, was on board Space Shuttle *Atlantis* in May 2009, operating the robotic arm used to upgrade the Hubble Space Telescope. Fellow alumna Jessica Meir (below), who received her PhD in 2009, traveled to the International Space Station (ISS) in September 2019. She made history a month later when she took part in the first all-female spacewalk. McArthur was scheduled to pilot a SpaceX mission to the ISS in 2021.

Children take in the denizens of the 70,000-gallon replica kelp forest at Birch Aquarium at Scripps. The aquarium hosts 500,000 visitors every year and offers a variety of educational programs for children.

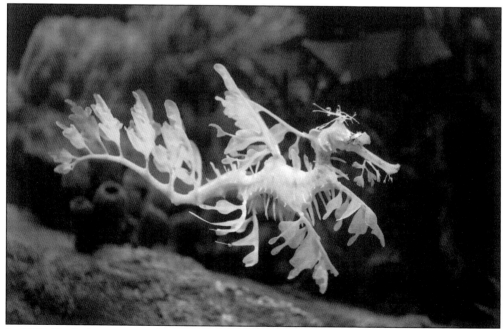

In 2019, Birch Aquarium at Scripps hosted one of the world's largest seadragon habitats. The aquarium's animal husbandry team leads attempts to preserve populations of these rare fishes. In 2020, two seadragon eggs hatched, making the aquarium one of the few in the world to accomplish the feat.

R/V *Sally Ride*, named after the first female American astronaut and former UC San Diego scientist, entered service in 2016 as the newest member of the US research fleet managed by the University–National Oceanographic Laboratory System. R/V *Sally Ride* is classified as an Ocean Class vessel, with a range just over 10,000 nautical miles, and is used to explore ocean phenomena in the Pacific Rim. Constructed in Anacortes, Washington, the vessel made a whistle-stop in San Francisco on August 19, 2016 (above), crossing under the Golden Gate Bridge on its way to its berth. R/V *Sally Ride* visited the Scripps campus a week later on the way to its home port, the Nimitz Marine Facility in San Diego's Point Loma neighborhood.

In the late 2000s, Veerabhadran Ramanathan discontinued field research to devote more time to raising awareness about the potentially existential threat climate change posed to society. He has enlisted the help of religious leaders in his quest, including the Dalai Lama (above). Ramanathan has been a member of the Pontifical Academy of Sciences since 2004 and has also worked with Pope Francis (below) on the creation of the 2015 encyclical *Laudato Si*, which addressed the fact that the world's poorest people will suffer the greatest impact of climate change despite contributing the least to the problem. An online book and course called "Bending the Curve," led by Ramanathan, has offered the public an opportunity to understand the magnitude of the problem and strategies to address it.

Scientists on board the *Sea Dipper* service a wave-monitoring buoy that is part of the roughly 70-station Coastal Data Information Program (CDIP) based at Scripps. Primarily funded to support wave and coastal erosion research, the network has become a lifeline for users ranging from surfers looking for local wave heights to cargo ship captains maintaining under-keel clearance as they approach ports.

Birch Aquarium at Scripps aquarist Ian Young makes the daily reading of ocean temperature at Scripps Pier in August 2018. In that same month, aquarists recorded the highest sea-surface temperature reading, 78.6 degrees Fahrenheit, in the 102-year history of the measurement series. The record was matched in 2020.

Socially distanced in response to COVID-19 protocols, the science team of the summer 2020 CalCOFI cruise led by Angela Klemmedson poses aboard R/V *Sally Ride* on July 22, 2020. The cruise made history when, by chance, all members of the team were women for the first time. (Courtesy of Angela Klemmedson.)

Scripps climate scientist F. Martin Ralph has advanced the study of phenomena called "atmospheric rivers," channels of water vapor in the atmosphere that are responsible for most of California's precipitation and often make the difference between drought and water abundance in the state. Ralph works with California and federal officials to determine how atmospheric river forecasts can improve the management of reservoirs throughout the state.

Scripps biological oceanographer Lisa Levin (center) describes marine organisms collected during a trawl to student Daniel Conley during a November 2015 cruise off the California coast. Levin has led research on the dynamics of seafloor ecosystems and discovered that even miles below the surface, there is evidence of human disruption. (Courtesy of Cody Gallo.)

Scripps student Andrew Mullen watches the behavior of corals using a benthic underwater microscope. Oceanographer Jules Jaffe and his team, including Mullen, developed the microscope to observe marine life at near-micron scales, giving researchers their first chance to do so without having to take samples of living organisms back to a lab.

From left to right, researchers Jennifer Smith, Samantha Clements, Nicole Pederson, and Emily Kelly encounter a frogfish within Kahekili Herbivore Fisheries Management Area off Maui, Hawaii. These Scripps marine biologists and others began the 100 Island Challenge in 2015 to document the evolution of coral reefs around the world in the face of human encroachment. (Courtesy of Emily Kelly.)

Scripps Oceanography researchers have studied the most remote places on Earth to contrast how naturally functioning ecosystems work with others that are under pressure from overfishing and pollution. Here, coral reef ecologists survey coral off the central Pacific Ocean island of Palmyra for signs of disease.

Margaret Leinen became the 11th director of Scripps Institution of Oceanography in July 2013. She had previously been an assistant director at the National Science Foundation, where she influenced the development of programs in marine, atmospheric, and earth science. As Scripps director, she represents science in several roles, including as a member of the executive planning group for the United Nations' Decade of Ocean Science for Sustainable Development.

A plaque marks the location on the Scripps campus where artifacts from La Jolla's earliest known residents, the Kumeyaay, were found. Today, initiatives to enhance Native American representation at UC San Diego and in the broader science community coincide with a growing global recognition of the value of Indigenous knowledge as a guide for sustainable management of the environment.

The Scripps biologist Martin Johnson and his wife, Phyllis, raised two children in one of the cottages on campus after he joined Scripps in 1932. Today, their small home remains known as the Martin Johnson House but is used for conferences, receptions, and weddings. It is one of several venues available for rent on the Scripps campus.

The Robert Paine Scripps Forum for Science, Society, and the Environment, also known as Scripps Seaside Forum, received an Orchid Award from the San Diego Architectural Foundation in 2009, the year it was completed. The complex also features four conference rooms. It is one of the most popular wedding locations in San Diego.

The city of San Diego declared October 19, 2017, Walter Munk Day in honor of the researcher's 100th birthday, installing honorary "Walter Munk Way" signs in La Jolla's Kellogg Park. Several days of celebration drew well-wishers ranging from top military officials and legislators to Prince Albert II of Monaco (below). In his later years, Munk, referred to as "the Einstein of the oceans," frequently implored his fellow researchers to pursue daring science and embrace risk. After a nearly 80-year career at Scripps, Munk died on February 8, 2019, at the age of 101 at his home just north of campus.

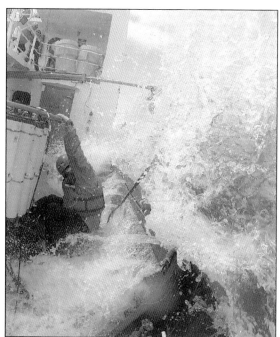

Whatever it takes to get the data: research technician Dave Faber hangs on as gale-driven waves crash onto the deck of R/V *New Horizon* during a cruise for the CalCOFI program in 2015. Researchers were there studying a large, mysteriously warm "blob" of water in the north Pacific Ocean, determining its effect on climate and open-ocean ecosystems. (Courtesy of James Wilkinson.)

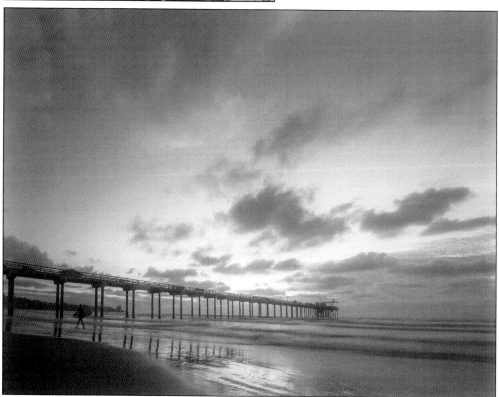

The Scripps Pier takes in another sunset. Like the rest of the world, Scripps Institution of Oceanography faces a future filled with new risks of society's making but also with the opportunity for solutions that accompanies the ingenuity and enthusiasm of new generations of scientists.

BIBLIOGRAPHY

Brueggeman, Peter. "Scientific Diving at Scripps Institution of Oceanography, a Concise History." *Mains'l Haul, A Journal of Pacific Maritime History* 52, no. 1 and 2 (2016): 8–21.

Day, Deborah. "Overview of the History of Women at Scripps Institution of Oceanography." UC San Diego Women's Center, San Diego, CA, October 14, 1999.

Morgan, Judith, and Roger Neil. *A Biography of Roger Revelle*. San Diego, CA: Scripps Institution of Oceanography at UC San Diego, 1996.

Raitt, Helen, and Elizabeth Moulton. *Scripps Institution of Oceanography: First Fifty Years*. Los Angeles, CA: The Ward Ritchie Press, 1967.

Shor, Elizabeth Noble. *Scripps Institution of Oceanography: Probing the Oceans 1936–1976*. Encinitas, CA: Tofua Press, 1978.

Ritter, William. "The Marine Biological Station of San Diego—Its History, Present Conditions, Achievements, and Aims." *University of California Publications in Zoology* 9, no. 4 (1912): 137–248.

Discover Thousands of Local History Books Featuring Millions of Vintage Images

Arcadia Publishing, the leading local history publisher in the United States, is committed to making history accessible and meaningful through publishing books that celebrate and preserve the heritage of America's people and places.

Find more books like this at
www.arcadiapublishing.com

Search for your hometown history, your old stomping grounds, and even your favorite sports team.

Consistent with our mission to preserve history on a local level, this book was printed in South Carolina on American-made paper and manufactured entirely in the United States. Products carrying the accredited Forest Stewardship Council (FSC) label are printed on 100 percent FSC-certified paper.